Oribe

FAMOUS CERAMICS OF JAPAN 8

Oribe

Takeshi Murayama

KODANSHA INTERNATIONAL LTD.
Tokyo, New York, San Francisco

Translated by Lynne E. Riggs

Distributed in the United States by Kodansha International/USA Ltd., through Harper & Row, Publishers, Inc., 10 East 53rd Street, New York, New York 10022.

Published by Kodansha International Ltd., 12–21 Otowa 2-chome, Bunkyo-ku, Tokyo 112 and Kodansha International/USA Ltd., 10 East 53rd Street, New York, New York 10022 and 44 Montgomery Street, San Francisco, California 94104.

LCC 82–80651
ISBN 0–87011–530–8
ISBN 4–7700–1043–5 (in Japan)

Library of Congress Cataloging in Publication Data

Murayama, Takeshi.
 Oribe.

 (Famous ceramics of Japan; 8)
 Translation of: Oribe. 1976.
 1. Oribe pottery. 2. Furuta, Shigenari,
1544?–1615. I. Title. II. Series.
NK4340.07M813 1982 738.3'7 82–806551
ISBN 0–87011–530–8 (U.S.)

Oribe Pottery

ORIBE IN THE HISTORY OF JAPANESE CERAMICS

The first ceramics to be used in the Japanese world of tea ceremony were *tenmoku* teabowls brought from China by Zen monks and celadon flower vases and water containers brought by trading vessels from Southern Sung China. As was fitting to the ostentatious style of the tea ceremony of the Higashiyama period (late sixteenth century), the paintings and other art objects displayed were all imported from China.

The father of the modern tea ceremony, Murata Shukō, put aside the costly and excessively formal pieces from China in favor of a more somber taste, using much more humble utensils for drinking tea. A look at the subdued color of the celadon teabowl we today call Shukō celadon gives us some notion of the ideals he sought to establish in the tea ceremony. The tea of Takeno Jōō took this aesthetic one step further by encouraging the asceticism—the "cold and withered" —of what came to be known as *wabi-cha*. He used everyday bowls made by anonymous potters of Yi dynasty Korea to introduce the spirit of simplicity to the tearoom.

The aesthetic of *wabi-cha* was further refined and perfected by Jōō's student Sen no Rikyū, who asserted that the tea ceremony should be unpretentious —"simply boiling water and drinking a cup of tea." Rikyū sought to instill a religious aspect in the tea ceremony. In order to give concrete form to the ideals he sought, he determined to make a teabowl expressly his own. He commissioned the head of the Raku family of potters, Chōjirō, for the task, and the first Raku teabowls were made. As Rikyū had stipulated, they were modestly shaped and focused inward. His specific choice of black for the teabowl, too, was intended to symbolize the meditative spirit of tea he taught. Indeed, this type of teabowl is an eloquent symbol of the medieval quality of mystic search.

At the dawn of the Edo period, after Rikyū's death (1591), one of the leading masters of tea was Furuta Oribe, distinguished general of that strife-torn period. It was only natural that the taste of Oribe's time should favor tea utensils that were robust, generous, vigorous, and distorted in shape. And to the simple philosophy of drinking tea that Rikyū had taught, the tea men of that time, with Oribe at their head, added the pleasures of companionable eating and drinking. To meet the expanded needs of their tea and dinner parties, eating and drinking utensils, including serving dishes, covered dishes, saké bottles, and saké cups, became necessary. These utensils began to be made at the Oribe kilns, and at Karatsu, Agano, and Takatori, and all were drawn together by the governing taste of Furuta Oribe. The pieces that were produced were typical of the flowering of craftsmanship that was part of the renaissance of art that occurred in the Momoyama period (1573–1615), brightly colored and gaily decorated in original and creative ways. The rustic character of the provincial warrior was, so to speak, tamed and refined in the flow of time, flowering magnificently in the Momoyama period.

Pottery that was artlessly made could attain a strength of character not present in the carefully and skillfully worked, revealing the unadorned essence of the material. Quite apart from the earlier lineage of Mino pottery, the magnificent Oribe designs are plainly the outgrowth of the tremendous cultural wealth of the Momoyama period.

After Oribe's death, as the feudal system of the Tokugawa shogunate became established, peace and stability settled over the country. The dynamic, creative Oribe pottery gradually faded into the shadows. And succeeding "Oribe taste" was "Enshū taste," established by the tea master Kobori Enshū (1579– 1647). With this new aesthetic trend, the pottery that enjoyed greatest popularity was the finely built, delicately glazed works of the so-called Seven Kilns that Enshū supervised.

With the middle Edo period, this aesthetic gave way

in turn to the more ostentatious aristocratic tastes preferred by Kanamori Sōwa and his contemporaries, as typified by the pottery of Nonomura Ninsei. Toward the end of the Edo period, Japan's leaders in aesthetic taste, including Mokubei and Nin'ami, began to lose interest in the traditional tea ceremony centered around powdered tea (*matcha*) and to turn instead to the esoteric, literati preferences of *sencha* connoisseurship.

FURUTA ORIBE

"Oribe" most commonly refers to the type of Mino pottery characterized by the presence of green glaze. In fact, however, the term may be interpreted as encompassing all the Mino wares—Shino, Yellow Seto, as well as Oribe in the strict sense—because they belong to what is known as "*Oribe-gonomi*," that is, they were liked and chosen by the great tea master Furuta Oribe (1544–1615). Also, Oribe ware using green glaze containing copper may be called Oribe in a very narrow sense. Of course, Oribe also refers to the man—Furuta Oribe himself.

Oribe was born in a wealthy landowning family of Mino. His grandfather Minbu and father, Shigesada, had served the local Toki and Saitō clans through two generations. Oribe, however, was a retainer of Oda Nobunaga (1534–82), later Toyotomi Hideyoshi (1536–98), and finally Tokugawa Ieyasu (1542–1616), thus serving the three most powerful figures in the turbulent period that bridged medieval and premodern times in Japanese history.

As a child, Oribe was called Sasuke or Kosa; his first name as an adult was Kageyasu, and he was later known as Furuta Oribe no Shō Shigenari or simply Koori (a shortened form, taking the first characters of his family and given names).

After Nobunaga died in 1582, Oribe distinguished himself under Toyotomi Hideyoshi in the battles of Yamazaki (1582), Shizugatake (1583), Komaki, the capture of Kishū (present-day Wakayama and Mie prefectures), and in other ways, earning the title Oribe no Shō of the lower fifth rank and receiving the fief of Nishigaoka of the province of Yamashiro (in the present-day metropolitan area of Kyoto) with a value of 35,000 *koku*. He was singled out to join the group of Hideyoshi's close confidants known as the *otogishū*, and after Hideyoshi's death devoted himself to the tea ceremony at his residence in Fushimi. It appears that

Oribe was famous as a master of the tea ceremony at that time, for in the March 22, 1599, entry of the *Tamon-in nikki*, the diary of the abbott of the Kōfuku-ji temple, it is recorded that "The prominent tea master, Oribe, came from Fushimi." At this time Oribe had already handed over his 35,000 *koku* fief in Yamashiro to his heir, Shigehiro, keeping lands of only 3,000 that had belonged to his father for himself. In 1600 during the Battle at Sekigahara, he again performed meritorious service in successfully taking a hostage from the lord of Hitachi, Satake Yoshinobu, and this brought him a reward from the Tokugawa of land worth 7,000 *koku* in the province of Ōmi, giving him territories totaling 10,000 *koku*.

As Tokugawa Ieyasu launched his winter offensive against the remaining Toyotomi forces at Osaka castle in November, 1614, Oribe and his son Shigehiro supported the Tokugawa side, and Oribe was wounded by a stray bullet. However, his youngest son, Kuhachirō, who was a page in the service of Toyotomi Hideyori, was suspected of passing Tokugawa secrets to the enemy castle, and a plan instigated by Hideyori through which Oribe's chief retainer Kimura Munetaka was to set fire to Nijō castle and turn against the Tokugawa after Ieyasu and his son Hidetada had left Kyoto for Osaka for the 1615 siege was discovered. This treachery inevitably implicated Oribe himself.

Caught in events he could not control, he is quoted as saying, "When such things come to pass, any words of innocence are wretched," and he carried out the expected *seppuku* (honorable suicide) at his home in Fushimi. His heir, Shigehiro, was also forced to kill himself, and the Furuta family was stripped of its lands and property. The Fushimi residence was given to the general Tōdō Takatora. Oribe was buried at Gyokurin-an at the Daitoku-ji temple, and a tomb and a wooden likeness of him are located at the Kōsei-ji temple at Nishijin, Kyoto. His posthumous Buddhist name is Kaneura Sōya.

In 1967, I paid a visit to Kōsei-ji to confer about borrowing the statue of Oribe for an exhibition. My antiquarian's curiosity took me to search for Oribe's grave in the quiet wooded cemetery. There in the twilight I was surprised to find a most ordinary, small monument, no larger than the many others that stood alongside it. All that set it apart was the base stone, added later, setting it slightly higher than the others. Even given the ill fortune into which the powerful of his time had pushed him at the end of his life, I

found it hard to believe that this was the tomb of one of the tea ceremony's greatest tea masters.

Sen no Rikyū, who was Oribe's tea ceremony teacher, was also forced to commit suicide, and one wonders if there was not some connection between the suicides of the two generations of tea men. Rikyū was sentenced on a spring day in 1591, and, fearful of the wrath of Hideyoshi, few friends save for Oribe and another famous tea master, Hosokawa Tadaoki, came to see the reclusive Rikyū off as far as the Yodo river crossing when he returned to his native Sakai to die. The previous year, from the encampment at Odawara during the offensive against the Hōjō, Rikyū had sent Oribe a letter—the now famous *Musashi Abumi no fumi*—that tells much of the friendship between the master and his disciple.

It is not completely clear when Oribe became involved in tea. Born in 1544, he was thirty-eight years old when his first liege lord, Nobunaga, was slain at Honnō-ji in 1582. Later in 1582, when Toyotomi Hideyoshi succeeded in unifying the country, Oribe was granted noble rank and became a provincial lord in Yamashiro. It was probably around this time that Oribe became known both as a distinguished general and a master of the tea ceremony. We know this from a letter written by Rikyū in the summer of 1582 mentioning Oribe in an invitation to accompany him to visit the Myoki-an tea house in Yamazaki. A note in the February 13, 1585 entry of the *Tsuda Sōkyū chanoyū nikki*[1] that one Furuta Sasuke had held a morning tea party, is further evidence of his prominence.

During the Keichō period (1596–1615), the *Sōtan nikki*[2] notes tea functions held at Oribe's Fushimi residence and states that the current shogun, Tokugawa Hidetada, was sometimes a guest at Oribe's tea gatherings. In 1610, Oribe went to Edo to teach Hidetada tea ceremony, and he became Hidetada's much revered mentor.

Oribe was numbered among Rikyū's leading disciples, men prominent both in power and in artistic connoisseurship, who included the so-called Seven Great Disciples: Gamō Ujisato, Hosokawa Tadaoki, Seta Kamon, Shibayama Kenmotsu, Takayama Ukon, Makimura Hyōbu, and Oda Uraku. That the son of a local landowner could rise to become one of the greatest tea masters of the day graphically illustrates the kind of social mobility that prevailed in that turbulent period. Some records, such as the *Kōshin hikki*, the tea journal of Kōshinsai Sōsa, the third son of Sen Sōtan (1577–1658), who was the fourth-generation master of the Omotesenke tea school, count Oribe as one of Rikyū's Seven Great Disciples, but the times were not always in his favor, and there are many tea records that do not include him in that elite group.

Rikyū boldly taught his students that the way of tea should foster an open-minded and creative inventiveness. A man who had survived by the sword the endless intrigues and strife of the period, Oribe's tea, unlike the relatively static, reclusive tea of Rikyū, forcefully expressed his personal preferences. So-called "Oribe taste" was robust, rough, magnanimous, free in form, an aesthetic surprisingly distant from that of Rikyū, whose preferences were best typified by the balanced tranquillity and introverted character of the early Raku teabowls.

Rikyū was a man who could use a teabowl, like his much loved Raku "Kimamori" bowl made by Chōjirō, over thirty-five times before his death and still not tire of it. Oribe's favored teabowls were of a humorous, distorted character, like the "comically flawed Seto teabowl used to serve tea" mentioned in the *Sōtan nikki*. Later tea men must have thought it almost sacrilegious to include among Rikyū's most favored disciples a man like Oribe, whose taste was so contrary to Rikyū's own modest preferences. And yet, it was Rikyū who believed that originality was the antithesis of imitation of others, and Oribe's way of tea was precisely what he had intended to teach. Though later tea masters have scrupled to include Oribe in their histories of tea, he was plainly a most worthy representative of a time that looked out upon the dawn of the modern age.

Mino Pottery

Mino pottery consists of Shino, Oribe, Yellow Seto, Seto Black, and Mino Iga ware, five types that were first made almost simultaneously. The process of glaze development was different for each of the five, but it is not possible to do more than touch on that topic and on other subjects such as the uses of vessels, structure of the kilns, and so on in this brief introduction.

Among the Mino glazes is Seto Black, a lustrous black iron glaze that recalls the teabowls of Chōjirō, the first generation of Raku potters. It is still not

completely clear what the connection between Raku and Seto Black was or which glaze was first used. Quite apart from any possible connection, nevertheless, we may note that while Raku had its beginnings in roof-tile kilns and utilized low-fired, lead glazes, Seto Black can be traced to the ash and iron glazes of old Seto ware.

Shino ware is characterized by its snowlike thick white glaze. It is Japan's first white-glazed ware, and, its very whiteness an invitation to decoration, it is Japan's oldest pottery with colored decorations. Unlike Oribe, Shino was fired in the pit kiln (anagama), which made possible the rich texture of its glaze. The earlier pieces are covered with feldspathic glaze low in natural silicon, which gives them a fleshy, nontransparent surface texture. The later the piece, the greater the proportion of silicon in the glaze and the more transparent the texture. Because of this effect, later Shino pieces begin to resemble decorated Oribe.

Yellow Seto, as the name implies, is a yellow ware whose basic color is provided by wood ash glaze. It again evokes the connection with Old Seto (ko-Seto) ware, which was fired in nearby Seto in former times. We can easily imagine that Old Seto ware exerted influence over the production of Yellow Seto in the Mino area. It can be argued that Yellow Seto ware has its origins in Old Seto pottery made for daily use, and that Yellow Seto as a ceramic art was first simply yellow Seto pottery in the broad sense; this later became the mainstream of so-called Yellow Seto.

Indeed, excavated examples of Yellow Seto go back to very early times. Yellow Seto has been found, for example, in the remains of Ōmori Castle built in Kanimachi, Mino, in the Eiroku period (1558–70). The castle of a provincial lord named Okumura Matahachirō Motonobu during the early Tenshō period (1573–92), it fell in 1583 to another provincial lord, Mori Chōka, and Okumura fled to the province of Kaga, where he became the guest of the powerful Maeda family. Along with the parched grains of rice used for soldier's provisions in the ruins of this castle were found a small Yellow Seto dish with impressed flower design as well as a tenmoku teabowl. Examples of Yellow Seto have been found in such castle sites not only in Mino, where they were made, but all over the country, indicating that Yellow Seto became one of the standard wares produced in this part of the country from the medieval period.

The history of Mino ware can be read in excavation sites other than those of the old kilns. For example, Oribe fired at the Yashichida kiln was found along with wooden bowls in the well of the residence of a man named Senmura, the head of a warrior band called the Kisoshū. An unusually remote site is that in Shinobu-chō, Iga-Ueno, where Black Oribe and a beautiful Yellow Seto shard with green copper glaze were unearthed. A Decorated Karatsu mukōzuke food dish (perhaps from the Kameya valley kiln) was simultaneously discovered.

More than ten years ago, when the Nihonbashi Post Office in Tokyo was rebuilt in its location behind the Takashimaya Department Store, several old Mino pieces were found. The chief of the construction work gave them to me. They included a small Yellow Seto dish, a Monochrome Oribe mukōzuke food dish decorated with a man on horseback and green Oribe glaze on the rim, and a small dish with a chrysanthemum design in iron glaze on the inside.

THE VARIETIES AND TECHNIQUES OF ORIBE

Green Oribe (ao-Oribe)

Green Oribe denotes ware that is partially covered with green copper glaze, the rest decorated with designs in iron glaze. One of the greatest attractions of Oribe ware in general is the beauty of this green glaze, and pieces of this variety are the most numerous.

The green copper glaze is made by blending a copper salt with feldspathic and wood ash glaze. The texture and depth of the green depends on the quality of the basic glaze. The older the piece, the simpler the method of mixing the glaze. Particularly important is the selection of the feldspathic glaze, and careful attention must be given to the quality of the oak ash, which is an important element of Shino and other glazes as well. The softer and more transparent the glaze, the more rich and vivid the green appears. The glaze is not applied with a brush, but by dipping or trailing or ladling on the piece; simple methods but, as the old pieces show, the most effective.

The dark line decorations accompanying the green glaze are done in iron made from brown iron ore, and again, there is considerable variation in this iron color, depending on the quality of the ore from which the glaze is made as well as the manner of firing. The transparent glaze over which the iron

decorations are applied is a blend of a small amount of wood ash glaze with feldspar.

Since green copper glaze turns red in reduction firing, Oribe is always fired in an oxidizing atmosphere. However, if the kiln atmosphere is completely oxidizing from the start, the green may be beautiful but thin (this can be given as the explanation for the dullness of many modern wares made with this glaze). For this reason, the imperfectly built kilns of ancient times, fired under completely natural conditions, were capable of creating magnificent pottery not reproducible by chemical science.

Monochrome Oribe (sō-Oribe)
This variety of Oribe is completely covered (except for the foot) with the copper green glaze and may be completely unadorned, have openwork patterns, or incised patterns underneath the glaze. The majority of incised designs are line drawings such as iris or men on horseback.

Narumi Oribe
This type uses both red and white clay together on the same piece; green glaze is applied over the white clay portion, and line decorations are painted in iron over a coat of white slip on the red clay. The subtle harmony of red, green, white, and black makes Narumi Oribe the most colorful of this kind of pottery. Some pieces are made with molds, including serving dishes, square dishes, and *mukōzuke* food dishes, and some are thrown on the wheel, such as teabowls and cylindrical *mukōzuke*. The latter include pieces with white clay sprigged on around the rim only, that is, where the green glaze is applied. In making molded pieces, such as flat *mukōzuke* or square dishes, the red and white clay is either placed on opposite sides of the mold or pressed together when the clay is put into the mold. It is a complicated procedure, but makes a decisive difference in the final effect, since the color of the green glaze is much more vivid when applied over white clay. All ceramics shrink approximately 20 percent in firing, and if the shrinkage rate for the two types of clay is different, the piece will come apart, so the technique requires thorough familiarity with the nature of the clay. Molded pieces often have the mark of fabric faintly impressed on the surface. This is the trace left by a layer of cloth placed between the mold and the clay to facilitate removal.

Until not long ago, I was once told, Narumi Oribe was believed to have gained its name because pieces of this type were made in the Narumi area of the present-day city of Nagoya. This idea may have arisen because of a presumed likeness to the bold resist-dyed cotton textiles of the area known as *Narumi shibori*. This dyeing, which developed under the protection of the Tokugawa lords of Owari during the Edo period, included many different types. There are many examples of Oribe ware, as in many other types of Japanese pottery, that show the use of textile patterns, including classical Chinese-style motifs. The influence of design between the worlds of textiles and pottery could have been mutual or could well have been only a one-way borrowing.

Red Oribe (aka-Oribe)
Red Oribe consists of pieces made with the techniques used in the red clay portions of Narumi ware, that is, pieces of red clay painted with white slip and decorated with line patterns in iron. This type of Oribe includes low *mukōzuke*, dishes, plates, small bowls, incense boxes, teabowls (*mukōzuke* adapted to use as teabowls); wheel-thrown *mukōzuke* are especially common.

Oribe Black (Oribe-guro)
Vessels glazed completely with black are known as *Oribe-guro*. Like Black Seto, they are taken from the kiln and cooled rapidly to bring up the luster of the black glaze; if left in the kiln to cool gradually, the black glaze grows somewhat brownish. This is a type common among teabowls, all of which are either of the "shoe" shape or cylindrical with some degree of distortion.

Black Oribe (kuro-Oribe)
The same glaze as for Oribe Black ware is used, but on only part of the piece. White glaze may be applied afterwards over the remaining portion of the vessel. Some are decorated further with iron on the white portion, or the decoration may be the white portion itself, surrounded by black glaze.

Shino Oribe (also called Plain Oribe)
This term identifies white Oribe that looks at first glance somewhat like Shino but is made in a chambered climbing kiln and has much more thinly applied feldspathic glaze of a lustrous quality resulting from increased amounts of silicon. Compared with Shino, it is a thin-walled, hard-fired ware and lacks the red tinge of the former.

Decorated Oribe (e-Oribe)

Shino Oribe with iron decoration is known as *e-Oribe*, or, as the late Tōkurō Katō called it, "*Oribe sometsuke*" ("printed" Oribe). Ash is added to the feldspar, and the ash glaze has an increased transparency that comes close to glass, which indeed gives the iron decorations the effect of having been printed on.

Mino Iga

The characteristic qualities of Iga ware are scorching (*koge*), glaze drips, and reddish tints. Especially beautiful is the effect created by cascading drips of natural glaze. Mino Iga imitates true Iga ware in shape and is covered with a thin overglaze. Iron glaze is dripped down the side of the pieces, taking the place of natural ash glaze runs. By far the majority of Mino Iga pieces are water containers for the tea ceremony, vases, and, rarely, teabowls. The shapes as well as types of vessels are usually patterned after early, prototypic Iga pieces.

TYPES OF VESSELS

Teabowls (chawan)

There are basically two varieties of Oribe teabowls, "shoe-shaped" or so-called *Oribe-gonomi* bowls and those originally made as *mukōzuke* dishes and later used as teabowls.

Dishes (hachi)

Serving dishes come in all sizes and numerous shapes: square, with indented corners, four-petaled, circular, "kimono-sleeve" shaped,[3] fan-shaped, etc. Some have openwork on the sides, are shaped like a *shamisen* plectrum, fitted with flaired feet, or are platterlike or bun-shaped. Dishes with handles, called *tebachi*, may be circular, square, or fan-shaped.

Lidded dishes (futamono)

Here, too, there are many common shapes: square, rectangular, indented corners, and fan-shaped, some with feet, some flat bottomed. The lid handles are modeled in a variety of abstract or realistic shapes.

Mukōzuke

These dishes for serving food in the *kaiseki* meal accompanying the tea ceremony are made in two basic types: deep (including "*nozoki*" or openwork pieces) and flat. Deep *mukōzuke* may be square, circular, fan-shaped, indented, and bulging, irregular shapes. Shallow *mukōzuke* come in countless stylized and many realistic shapes, including plectrum-shaped, fan-shaped, crescent-shaped, boat-shaped, flower-shaped, etc.

Incense boxes (kōgō)

Incense boxes, too, display numerous shapes patterned after such things as chrysanthemums, a warrior's helmet, fan, circle, square, and hats worn by court nobles in ancient times. The knob or handle on the lid is often cleverly modeled in the form of a fish, flower, bamboo branch, or simply an arc or loop.

Incense burners (kōro)

Incense burners have a great range of shapes, from realistic forms such as lions or owls to forms emulating certain Chinese celadon porcelains.

Water containers (mizusashi)

Water containers for the tea ceremony seldom display green Oribe glaze, but in most cases are of the Mino Iga type, whose shapes are reflections of Iga ware models.

Vases (hanaike)

Oribe ware includes very few vases, the best known being the square example shown in Plate 35.

Tea caddies (cha-ire)

The majority of Oribe tea caddies were made expressly for that purpose, either covered completely with iron glaze or with designs in white glaze added over the iron glaze. There are a very few tea caddies of bucket shape or cylindrical shape adapted from what were originally deep *mukōzuke*.

Saké drinking vessels (shuki)

Saké bottles are typically slender necked and tall bodied. Saké cups may be Monochrome Oribe pieces with flaired lip or hexagonal shape or hexagonal iron-glazed pieces. Originally these were made as *choku*, a type of small *mukōzuke*.

Saké bottles (chōshi)

Ranging from large to small, these bottles are of various kinds, some with lids or handles, tall and slender or low in construction.

Shaker or sprinkling bottles (furidashi)

These slender-necked, diminutive vessels include some green-glazed and some iron-glazed pieces.

Miscellaneous

There are, in addition, Oribe pieces that are not for eating or drinking, including utensils for writing

(inkstones and fish- or animal-shaped water droppers), pipes, lamps, saké cup stands, cup-shaped *mukōzuke*, folding screen stands, and even pulley wheels for ropes holding well buckets.

THE ORIBE KILNS

Motoyashiki (Kujiri)

This is the oldest kiln where Oribe ware was fired. The full range of vessels and styles was made here, and the overwhelming majority of important and famous works come from this kiln. Most of the Mino Iga pieces were made at Motoyashiki as well as imitation *tenmoku*, Yellow Seto, Shino, Seto Black, and even imitation Karatsu.

Shōbu (Kujiri)

Second only to Motoyashiki in the number of excellent pots made there, Shōbu (also called the Inkyo kiln) produced works of a slightly more refined quality. It is the birthplace of some excellent examples of Narumi and Red Oribe.

Kamane (Kujiri)

Along with Motoyashiki and Shōbu, Kamane is one of the leading kilns in Kujiri and one known especially for the production of Monochrome Oribe. Small dishes decorated with simple incised iris designs, grasses, or hatted men on horseback and dipped in green glaze are typical products of this kiln.

Yashichida (Ōgaya)

Located in Ōgaya, rather remote from the other Oribe kilns, Yashichida was near kilns that made Shino ware; the Yashichida ware is the most elegant and refined in proportion and design of all the Oribe styles. Light and fine of body, the vessels fired here are decorated with fine lines in iron, an intermediate color with white slip mixed in, and scant trails of blue-green glaze. The pottery of this kiln tends to be slightly underfired compared to other types of pottery, and this is perhaps because the clay could not withstand high temperatures.

So delicate is the quality of these pieces that some have speculated that the great Kyoto potter Nonomura Ninsei was in some way connected with the Yashichida kiln. However, it produced pottery in the "Oribe taste" in the broad sense only from Momoyama to the early Edo period, so it seems more likely that it was the reverse, that Yashichida influenced the Kyoto kilns, including that of Ninsei.

Seidayū (Ōhira)

The products of this kiln are rather inferior in workmanship to those of the Kujiri kilns. The clay tends to be somewhat softer than that of Kujiri, however, which might have made fine techniques actually easier to achieve. Square plates, handled dishes, and ewers are among the pieces most commonly made at this kiln.

Ōtomi

This kiln is believed to be the last to fire Oribe wares between the Momoyama and early Edo periods. Greater emphasis was given to miscellaneous utensils for popular use than to tea wares, and it is reasonable to think that this approach led the way in the general production of items for everyday use at the Mino kilns in the middle and latter part of the Edo period. The green copper glaze of pieces from this kiln is especially vivid, and there are some notable pots among its production.

MUTUAL INFLUENCE BETWEEN ORIBE AND KARATSU

Oribe and Karatsu pottery share similarities of both decoration and shape. For example, the lotus leaf-shaped *mukōzuke* dish is common to both types, as are such motifs as drying fish nets and plovers. In fact, in 1592 Furuta Oribe did go to visit the headquarters of the forces at Nagoya in Hizen (Kyushu) as a member of the rear guard in Hideyoshi's invasion of Korea, so it is possible that he made some contact with the Karatsu kilns at that time. Even aside from any efforts of Oribe himself, a look at the *mukōzuke* of the Koyamaji kiln at Karatsu would seem to be convincing evidence for a clear connection with Mino pottery.

Among the documents of Mino is one entitled *Seto ōkama yakimono narabi ni Karatsu kama toritate no raiyusho* ("An Account of the Pottery of the Great Kilns of Seto and the Introduction of the Karatsu Kiln"). The first half of the account records that the Nara period priest Gyōki Bosatsu (668–749) had first fired jars in a pottery village in Izumi Province (present-day Osaka) and includes the following passage:

> In Owari in the village of Seto there was a man named Katō Shiroemon who made tea caddies. Shiroemon's son came to this area [the postscript notes that it is a pottery village called Kujiri in Toki county in the province of Mino] and made pottery for several years.

. . . and then he was made a magistrate [in Mino]. A lordless samurai named Mori Zen'-emon who happened to be from Karatsu in Hizen came to Mino and, seeing the kiln of the magistrate, remarked, "What a shame, the fire is going to waste!" The magistrate then asked how kilns were built in Karatsu. When Zen'-emon returned to Hizen he took with him a manservant who learned how to build a kiln in the Karatsu manner. When he went back to Mino, the magistrate promptly had him build a kiln on the grounds of his estate and erected a high wall around it in the attempt to keep the secret of his new kiln from others. No matter how earnestly the potters of other kilns nearby begged to see it, he would not show them. So these men got together and decided to wait until the New Year would allow them an occasion to visit the magistrate's residence to pay their annual respects. Then one of them should stealthily contrive to get a look at the kiln. When the New Year came, a great banquet was held at the magistrate's residence, during which a young man named Ninhei, one of the sons of Matsubara Tarozō, left the hall on pretext of relieving himself and went out the gate and climbed into the high-walled enclosure. As he was carefully examining the kiln, he was discovered by a watchman, who shouted for help to catch the trespasser. In the ensuing furor, Ninhei's companions managed to flee, and he, too, was finally able to make his escape.

The ruins of this kiln in Mino remain today—the Motoyashiki kiln. The account has not been entirely authenticated, but it is interesting that even in those times, a potter might risk his neck for the sake of gaining techniques, which would increase his profits.

Oribe's Interest in Western Things

Some have speculated that Furuta Oribe was a Christian. He was related by blood to the great Christian daimyo Takayama Ukon, and there are, indeed, Oribe teabowls with the letters IHS (from Greek letters meaning Jesus) or with the cross inscribed on them. Also, on the front of the lower portion of a stone garden lantern known as the Oribe lantern there is a relief of a figure in a cloak believed to be a Christian or missionary. A document written by one Wataya Uhei in 1644 records that a lantern donated to the Tōgara Tenjin Shrine on Ōusumura in the western quarter of Kyoto was called the "Furuta Oribe Favorite Stone Lantern." However, as observed before, Oribe took his own life by ritual suicide, so there is still no convincing evidence that he was, in fact, Christian.

Conclusion

From the Momoyama through the early Edo period, Oribe ware rapidly developed in the great flowering of the ceramic arts at the time. Then the world of pottery began to shift toward the production of ceramics for popular everyday use, as typified by kilns such as Kasahara, and production of Oribe never again returned to its former glory. Late in the Edo period there was a revival of Oribe in the Seto area. Many fine pieces were produced by famous potters, including Shun'ei, Shuntan, Shuntai, Kurō, Shungyō, and Shunkozan, but I believe these belong to a separate category of inquiry.

In writing this manuscript, I would like to acknowledge with fond remembrance the opportunity to enjoy the "Seminars on Ceramics and Exhibition of Oribe Ware" and in 1967 the Exhibition of Great Works of Oribe" sponsored by the Japan Ceramics Association, where I am now employed. I am indebted to the valuable catalog and commentary the late Hajime Katō prepared for that showing. I am also grateful to Tadachika Kuwata for use of parts of his survey of Furuta Oribe's life prepared for that exhibit.

Text Notes

1. *Tsuda Sōkyū chanoyu nikki* (The Tea Diary of Tsuda Sōkyū). Also called the *Tennōjiya kaiki* (Tennōjiya Tea Journal). A record of the tea ceremonies held both by the Tennōjiya family (of Sakai, Osaka) and elsewhere, it extends over three generations from 1548 to the end of the Tenshō era (1592), recording some 2,560 tea ceremonies during the three generations.

2. Also known as the *Kamiya Sōtan nikki*. One of the three most famous tea diaries, it extends from the Tenshō era (1573–92) to 1644.

3. *irizumi* *mokko* *tagasode*

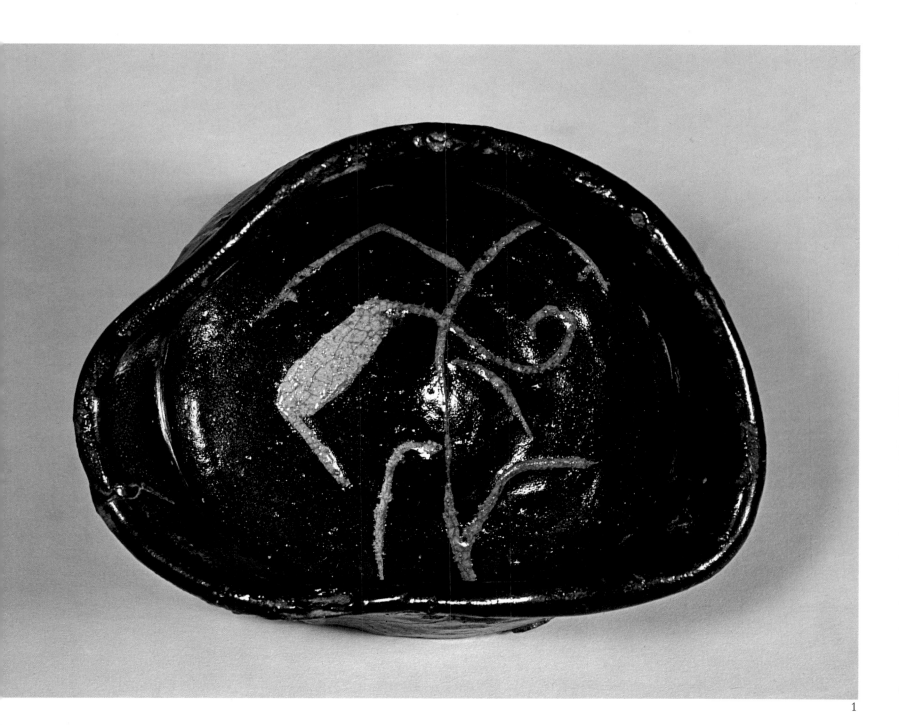

1

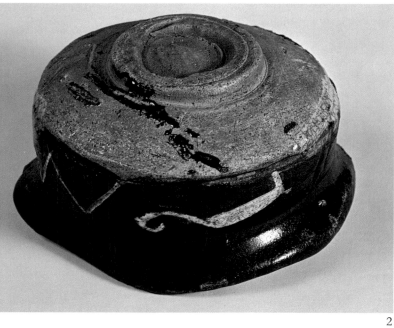

2

3

1–3. Black Oribe teabowl, lily design. D. 15.1 cm. Umezawa Memorial Gallery.

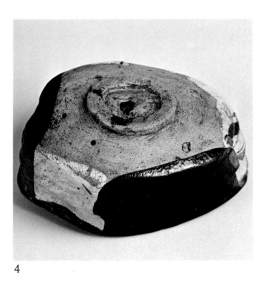

4

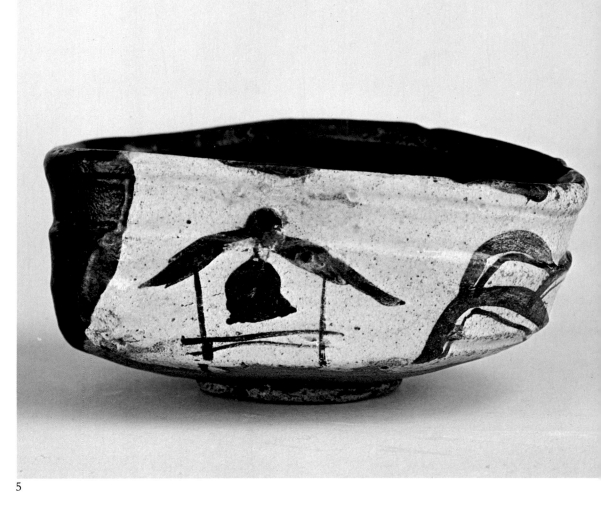

5

6

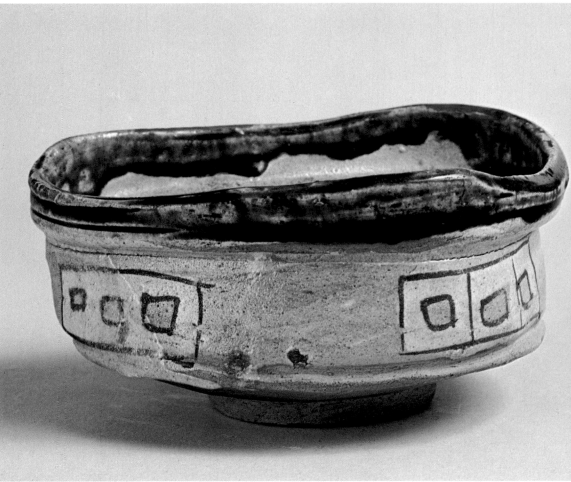

7

4, 5. Black Oribe teabowl, belfry design (name: "Dōjōji"). D. 13.8 cm.

6, 7. Narumi Oribe teabowl. D. 14.7 cm.

14

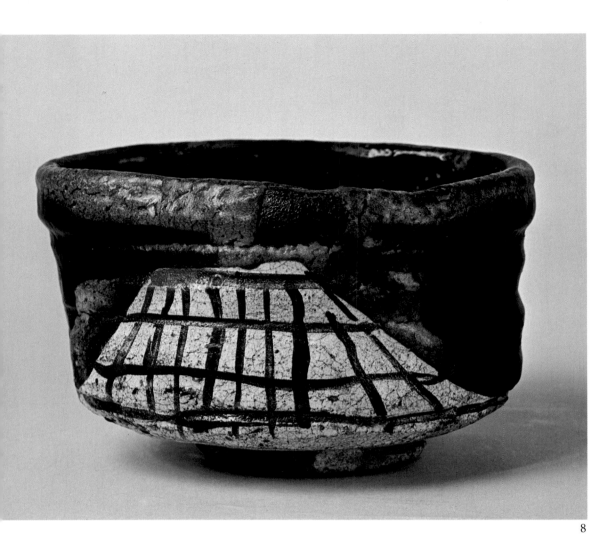

8

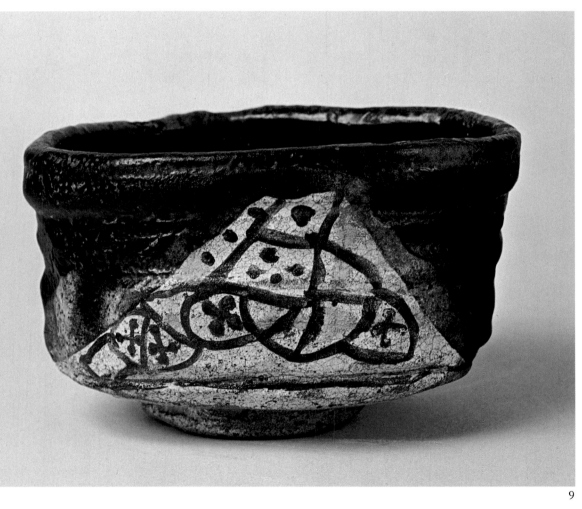

9

10

8–10. Black Oribe teabowl, Mt. Fuji design. D. 14.6 cm. Tokyo National Museum.

15

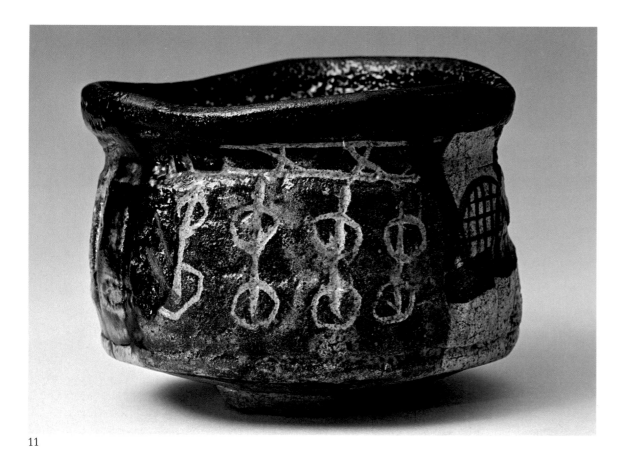

11

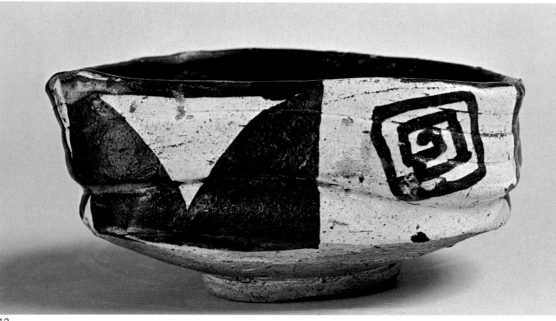

12

14

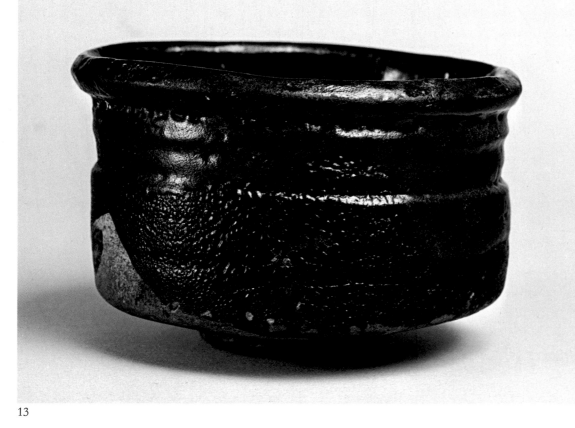

13

11. Black Oribe teabowl, dango *design. D. 12.3 cm. N
Art Museum.*

12. *Black Oribe teabowl, geometric design (name: "Shi*
gare"). *D. 14.3 cm.*

13. *Plain Black Oribe teabowl (name: "Unrin"). D. 1
cm.*

14. *Decorated Oribe pedestaled teabowl (bajōhai type).
12.8 cm.*

16

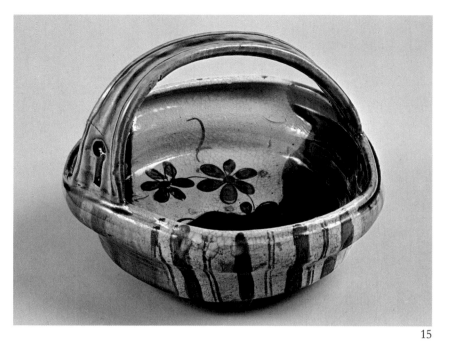

15

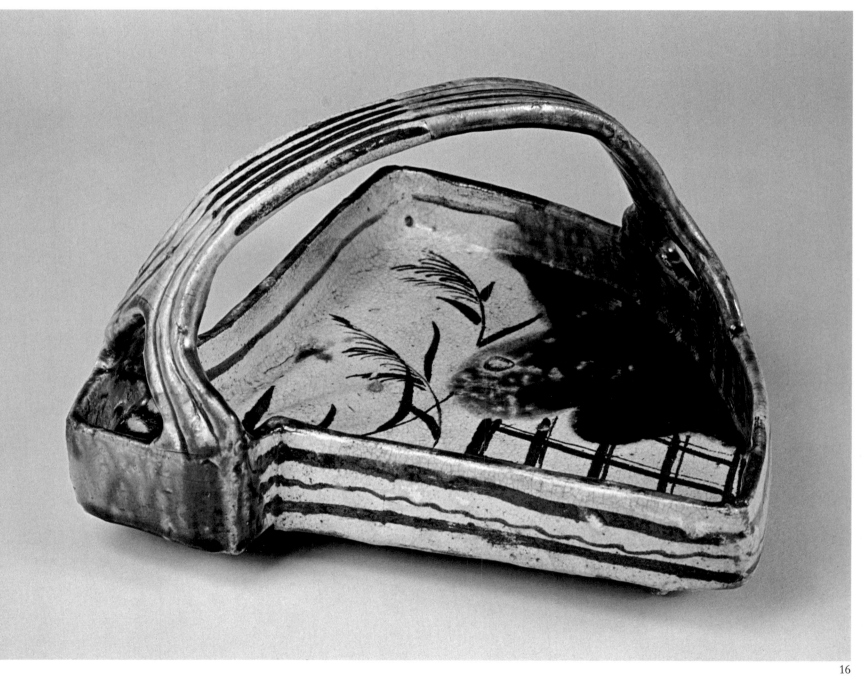

16

15. Handled dish. D. 23.8 cm. Idemitsu Museum of Arts.

16. Fan-shaped handled dish. L. 29.3 cm.

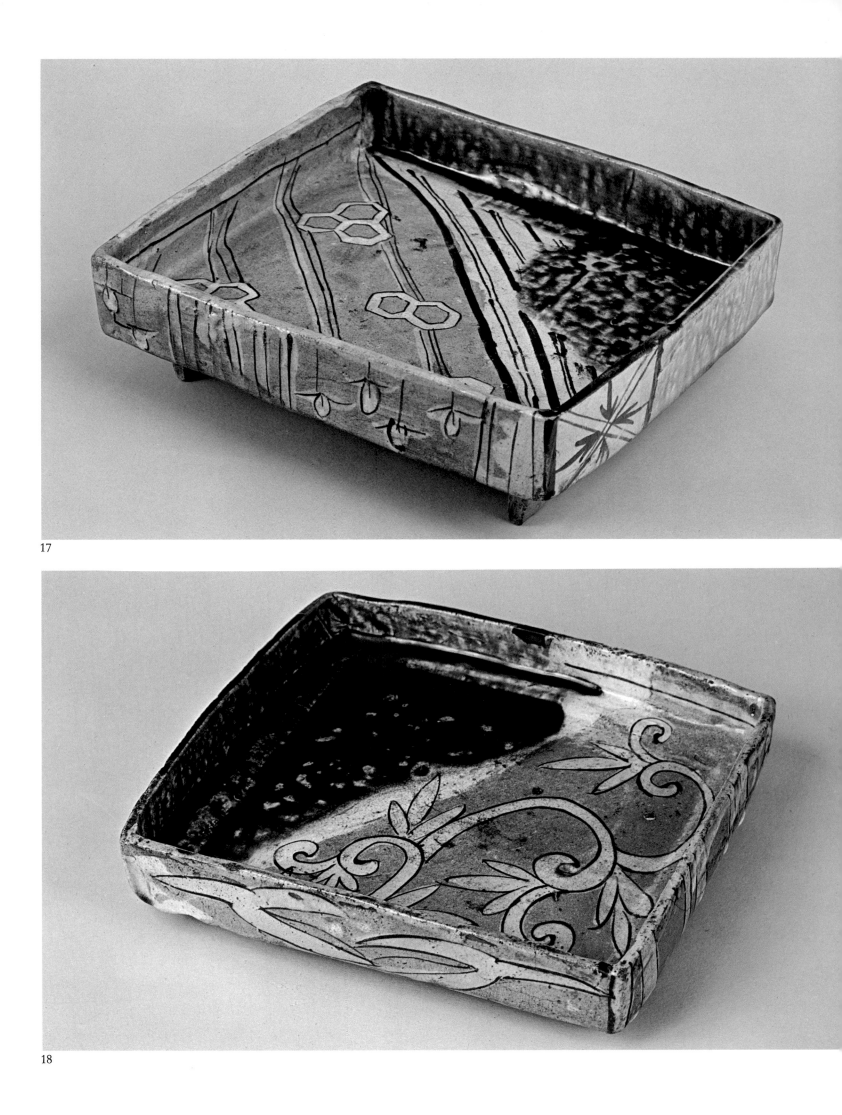

17

18

17. *Square dish, tortoiseshell pattern. L. 23.8 cm.*

18. *Square dish, floral scroll pattern. L. 21.5 cm.*

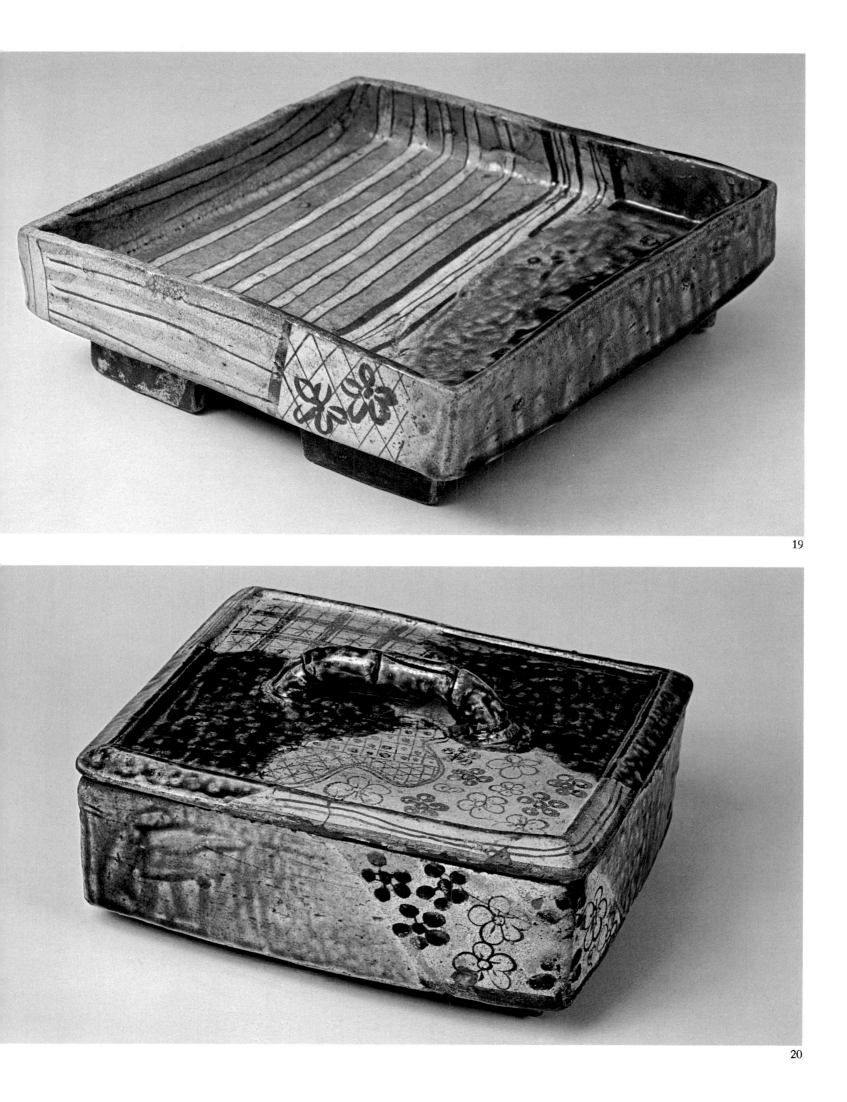

19

20

19. *Square dish, stripe pattern. L. 22.7 cm. Nezu Art Museum.*

20. *Rectangular lidded dish. L. 23.0 cm.*

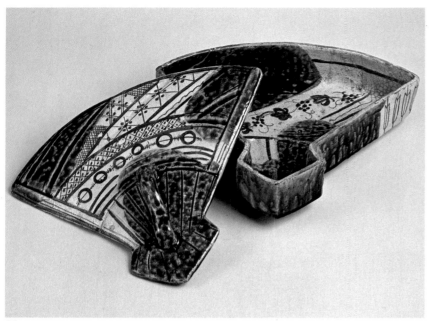

21

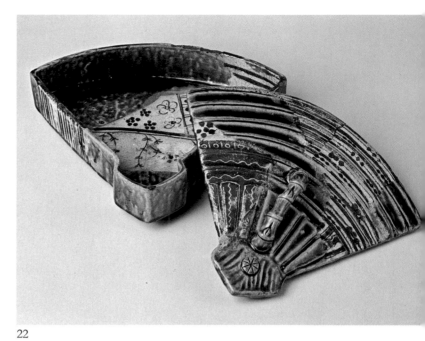

22

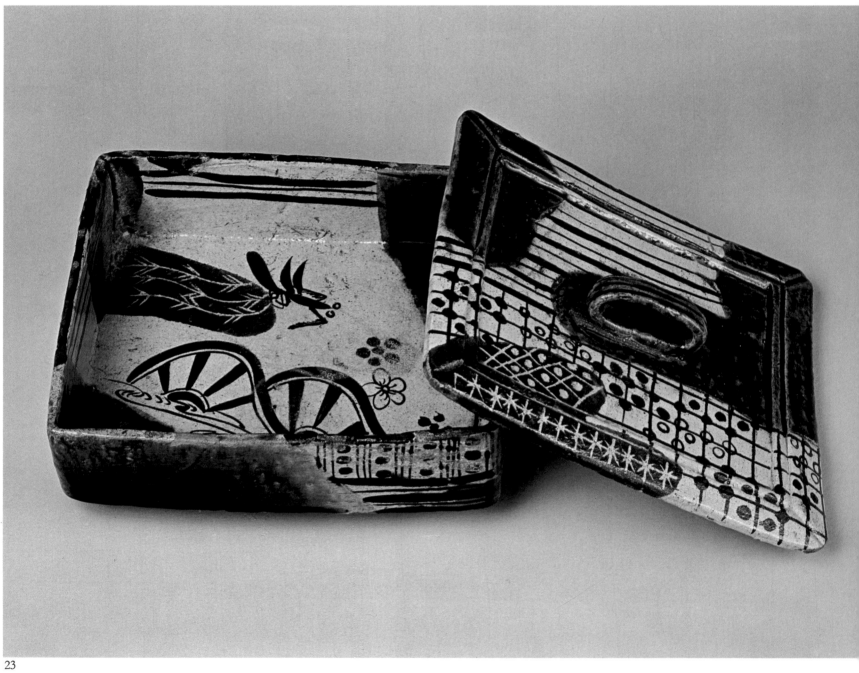

23

21. *Fan-shaped lidded dish. L. 29.8 cm.*

22. *Fan-shaped lidded dish. L. 28.4 cm. Umezawa Memorial Gallery.*

23. *Square lidded dish. L. 21.2 cm.*

24. *Square indented* mukōzuke *food dishes. L. 12.4*

25. *Plover* mukōzuke *food dishes. L. 13.8 cm.*

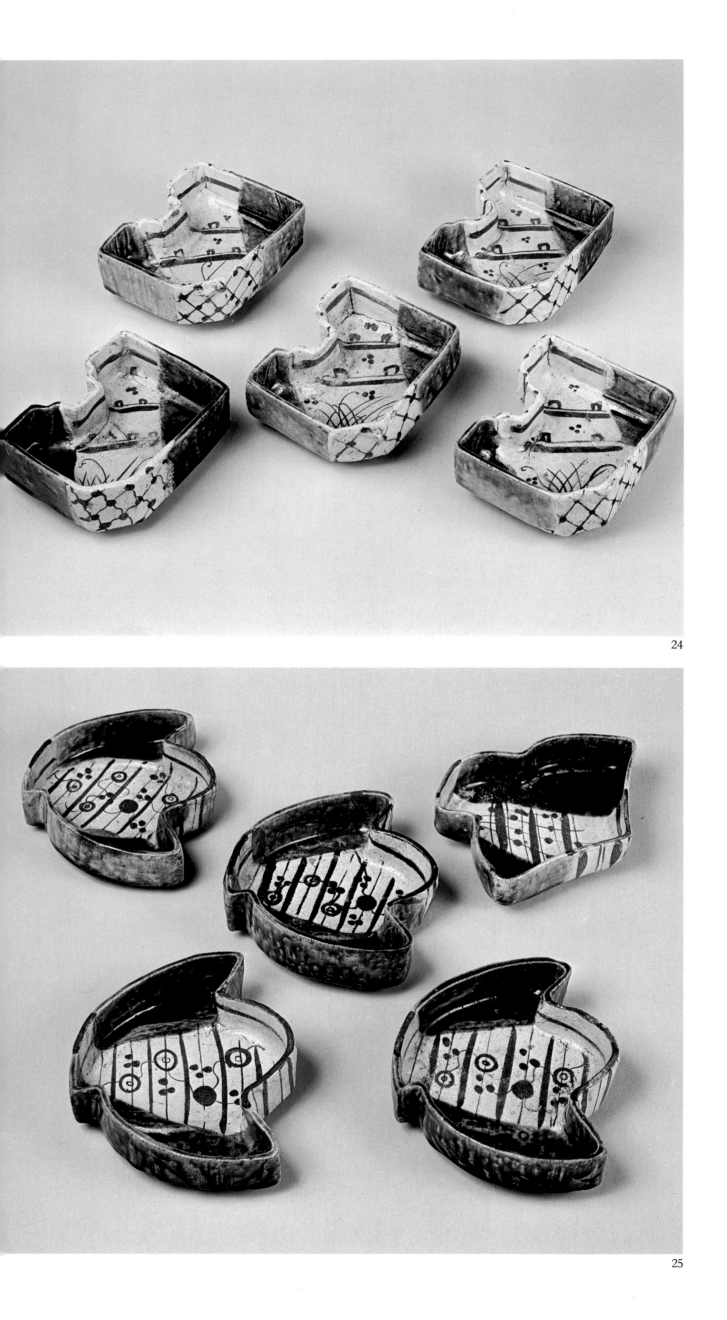

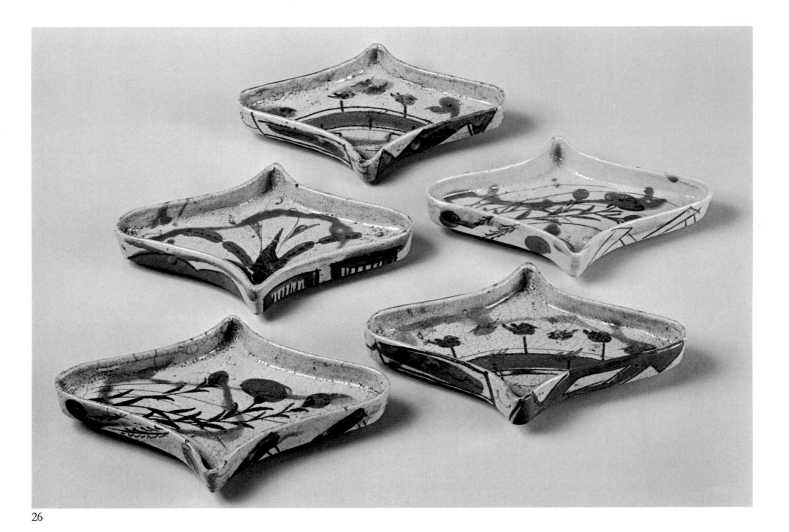

26

26. *Rhomboid* mukōzuke *food dishes. L. 20.3 cm.*

27. *Crescent-shaped* mukōzuke *food dishes. L. 15.8 cm.*

28. *Handled* mukōzuke *food dishes. Hatakeyama Collection.*

29. *Openwork* mukōzuke *food dishes. H. 11.3 cm. Umezawa Memorial Gallery.*

30. *Boat-shaped* mukōzuke *food dishes. L. 20.8 cm.*

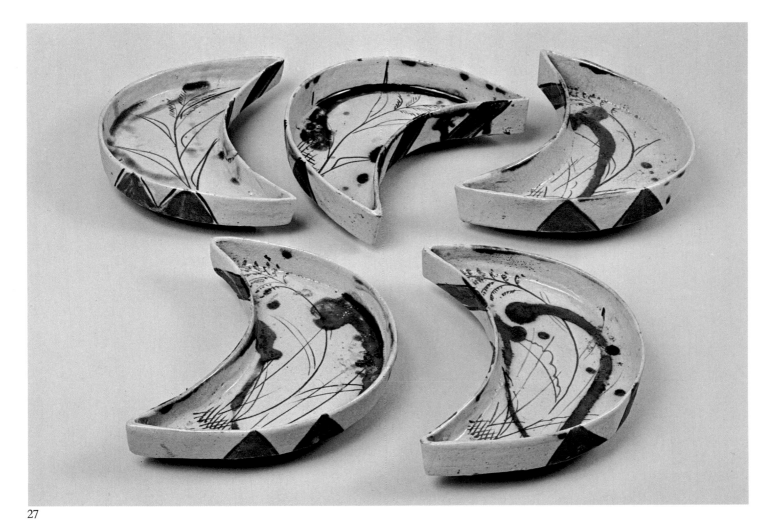

27

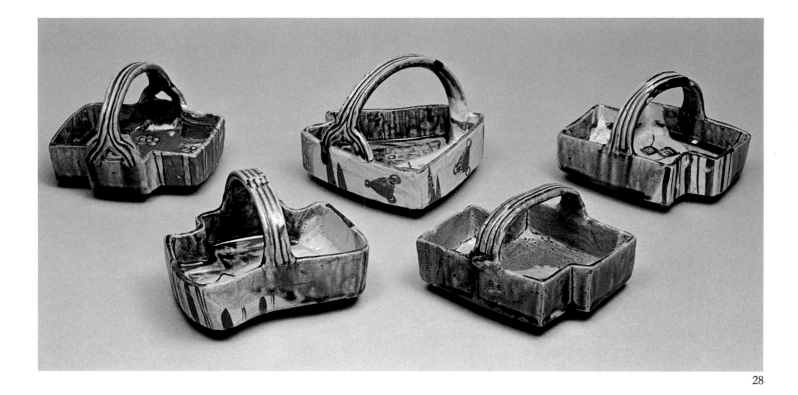

28

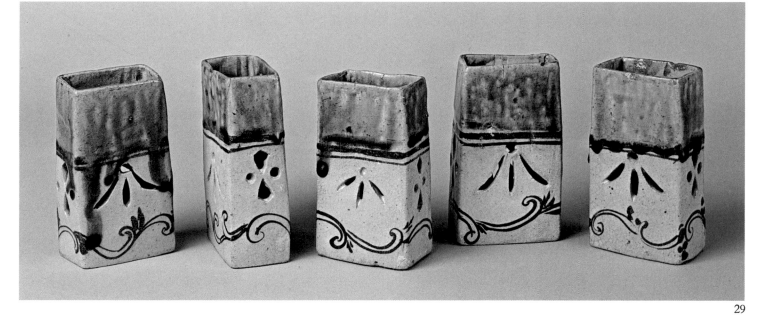

29

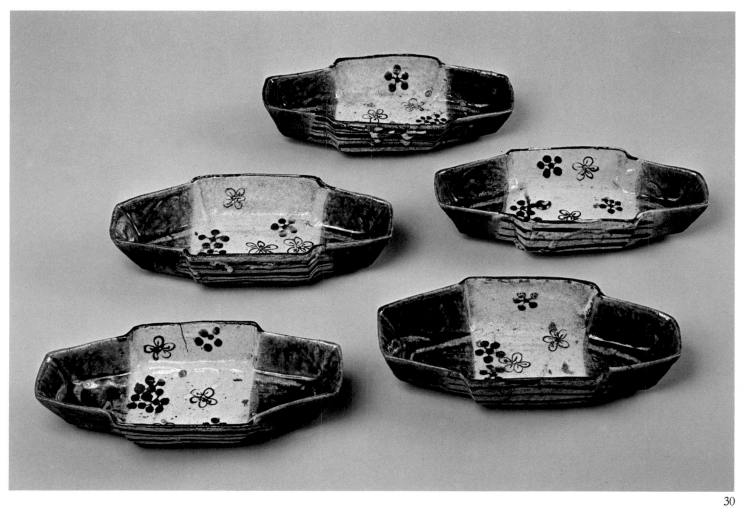

30

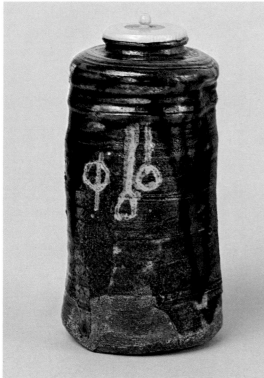

31

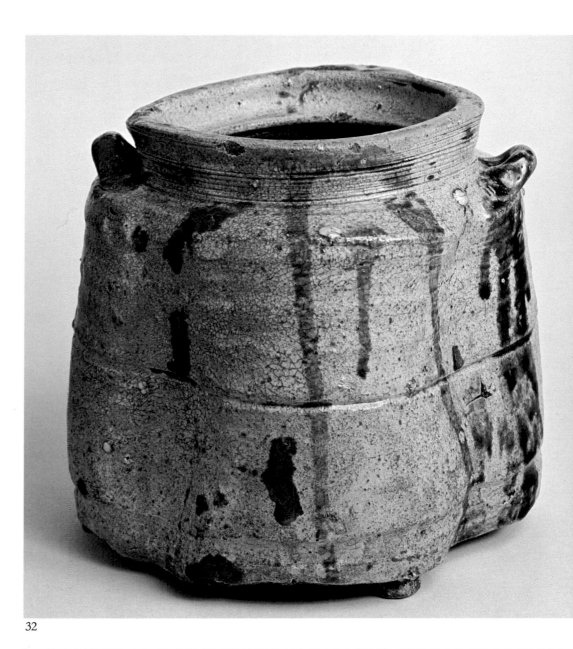

32

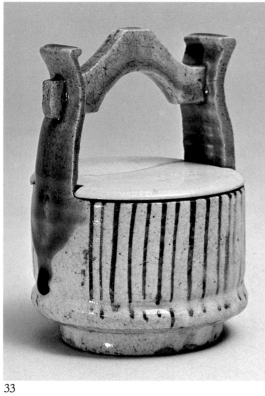

33

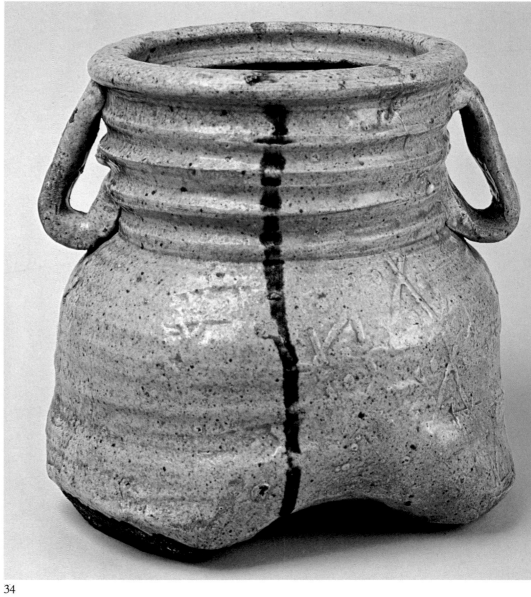

34

31. Tea caddy. H. 11.2 cm.

32. Eared Mino Iga water container. H. 18.6 cm.

33. Bucket-shaped tea caddy. H. 10.6 cm. Nezu Art Museum.

34. Eared Mino Iga water container. H. 20.3 cm.

24

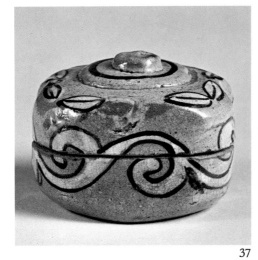

37

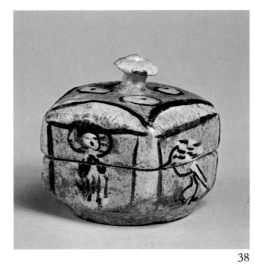

38

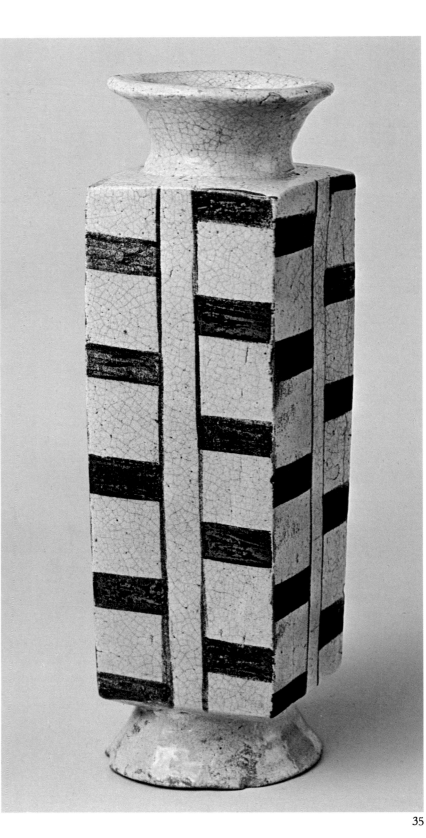

35

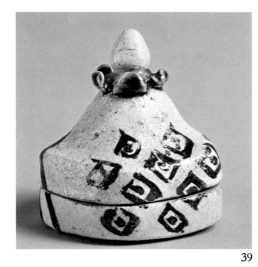

39

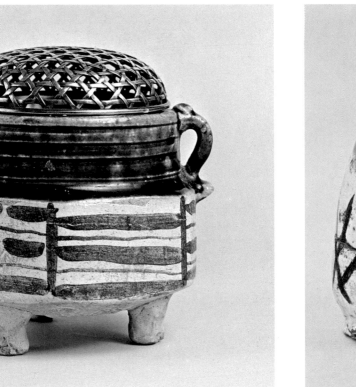

36

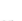

40

Vase, stripe pattern. H. 30.2 cm.
nezawa Memorial Gallery.

Incense burner with handles. H. 8.8

Incense box, scroll pattern. H. 4.1
Idemitsu Museum of Arts.

Square incense box, human and
d figures. H. 4.3 cm.

Pinnacled incense box (name:
higure"). H. 5.4 cm. Idemitsu Mu-
m of Arts.

Incense box, eggplant shape. H.
cm.

25

41. Bottle, diadem and grapevine design. H. 24.9 cm.

42. Monochrome Oribe saké cups. D. 6.0 cm.

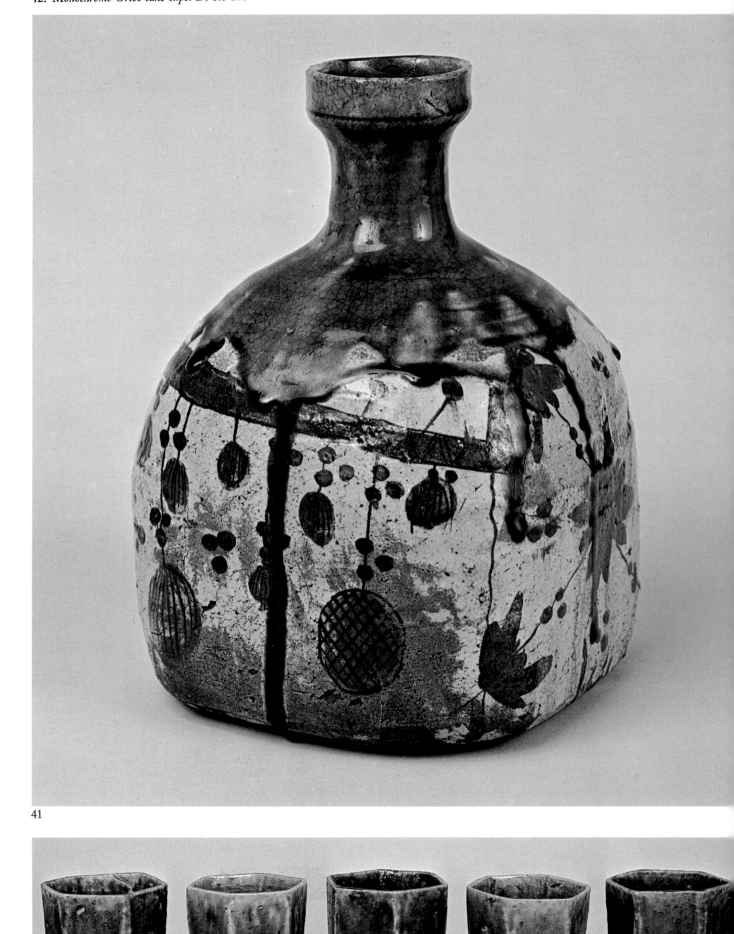

41

42

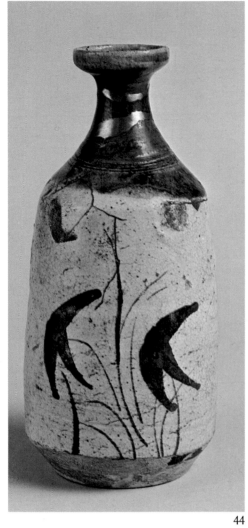

43. *Ewer with handle. H. 30.9 cm. Nezu Art Museum.*

44. *Saké flask, spatterdock design. H. 19.5 cm.*

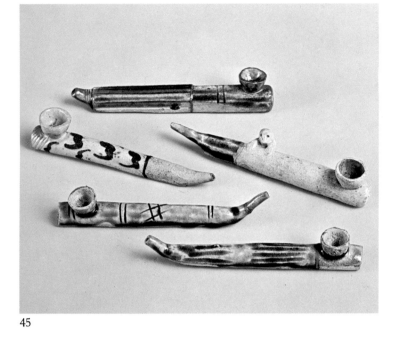

45

46

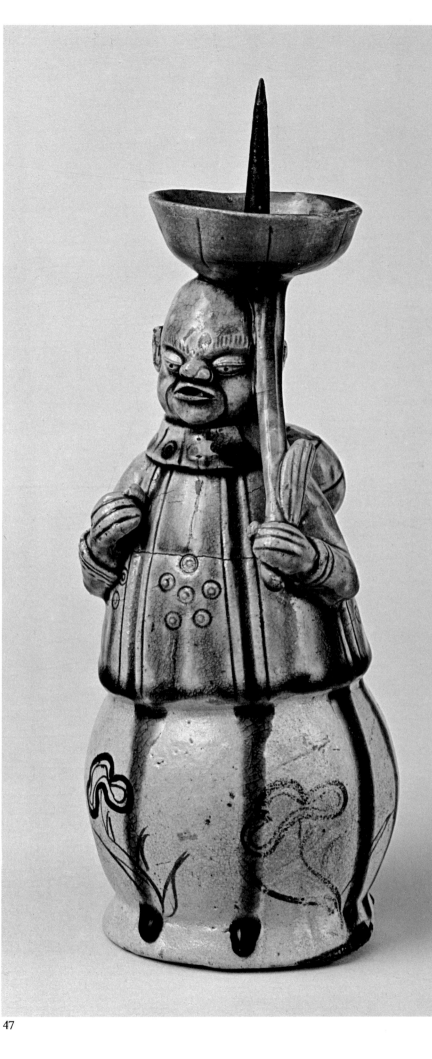

47

45, 46. *Pipes. Plate 45, L. 12.5 –13.4 cm.; Plate 46, L. 7.6–9.6 cm.*

47. *Candleholder figurine. H. 23.4 cm. Umezawa Memorial Gallery.*

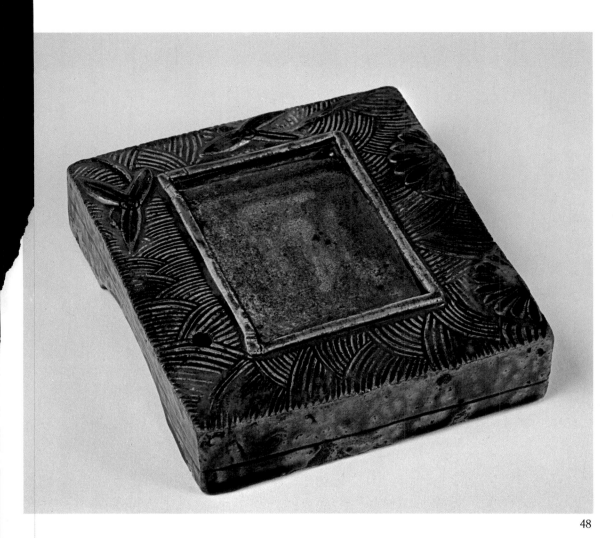

48

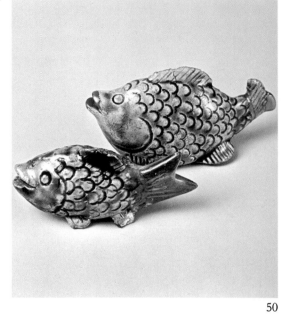

50

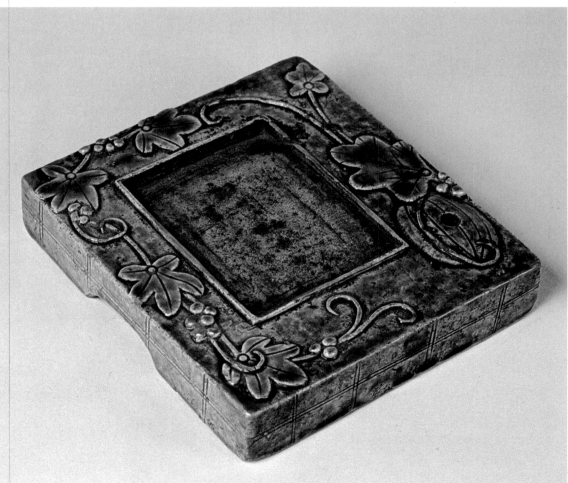

49

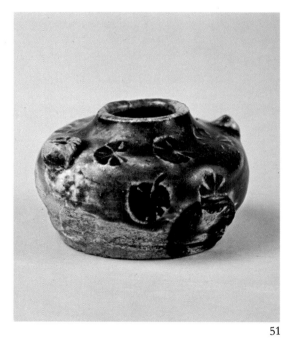

51

48. Monochrome Oribe inkstone, water-flower design. L. 16.8 cm. Umezawa Memorial Gallery.

49. Monochrome Oribe inkstone, squash-flower design. L. 17.0 cm. Tokyo National Museum.

50. Fish-shaped waterdroppers. Large, 11.1 cm.; small, 9.0 cm.

51. Monochrome Oribe flower-stamped waterdropper. H. 2.8 cm.

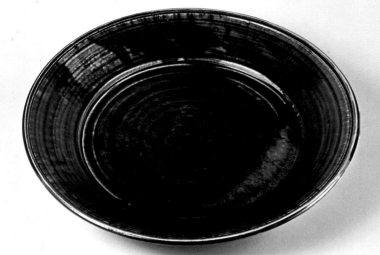

52

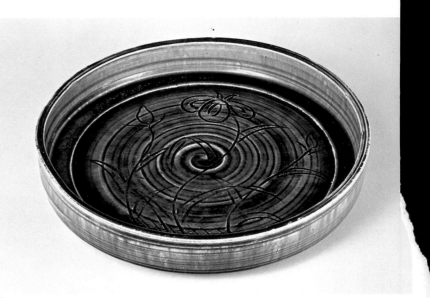

53

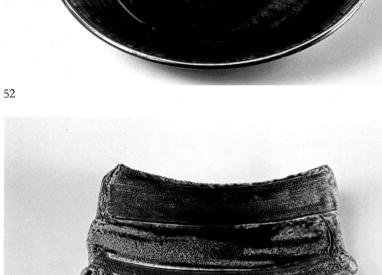

54

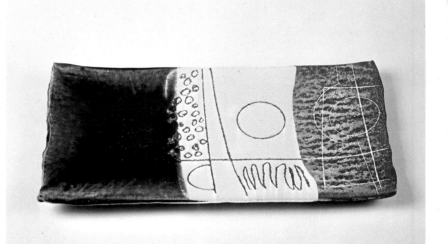

55

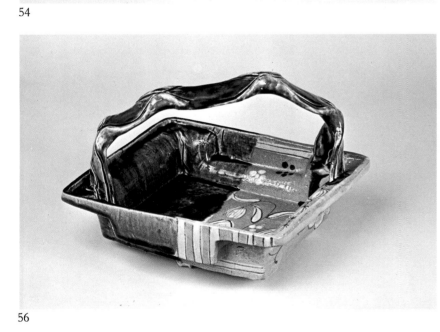

56

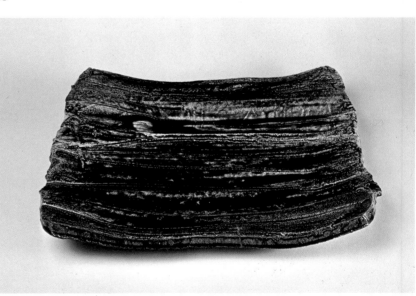

57

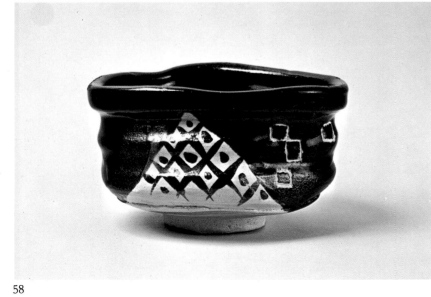

58

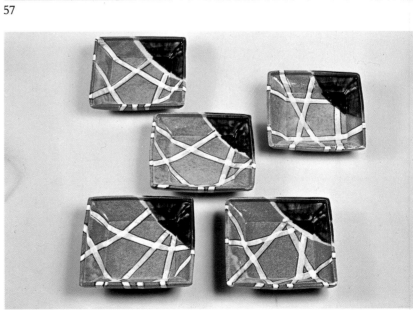

59

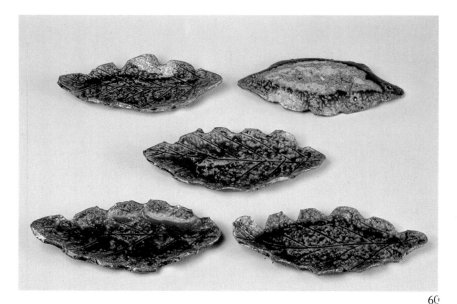

MODERN ORIBE

52. *Monochrome Oribe plate. D. 49.1 cm. Hidetake Andō.*

53. *Monochrome Oribe dish, iris design. D. 29.7 cm. Seizō Katō.*

54. *Monochrome Oribe plate. L. 32.3 cm. Yasuo Tamaoki.*

55. *Narumi Oribe plate. L. 40.7 cm. Toshisada Wakao.*

56. *Handled dish. D. 23.8 cm. Kiheiji Takiguchi.*

57. *Monochrome Oribe plate. L. 40.2 cm. Osamu Suzuki.*

58. *Black Oribe teabowl. D. 14.6 cm. Mitsuemon Katō.*

59. *Narumi Oribe* mukōzuke *food dishes. W. 16.2 cm. Kōtarō Hayashi.*

60. *Oak leaf-shaped dishes. L. 23.8 cm. Rosanjin Kitaōji.*

61. *Handled dish. L. 28.5 cm. Tōkurō Katō.*

62. *Handled dish. H. 16.4 cm. Takuo Katō.*

63. *Narumi Oribe teabowl. D. 13.0 cm. Tadashi Sasaki.*

64. *Monochrome Oribe flower vase. H. 26.3 cm. Shuntei Katō.*

60

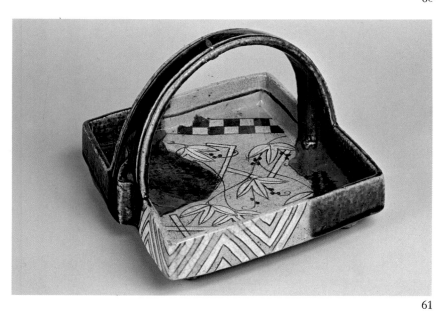

61

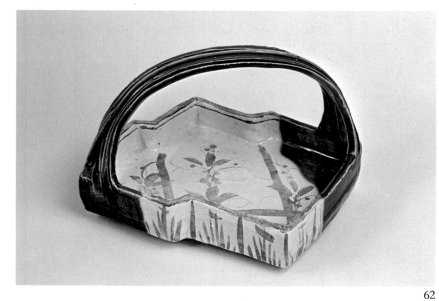

62

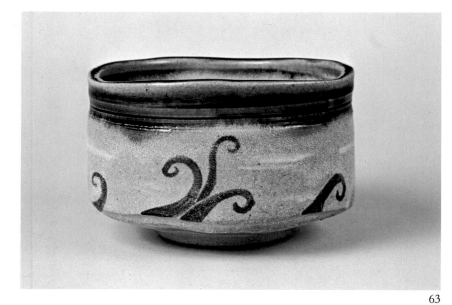

63

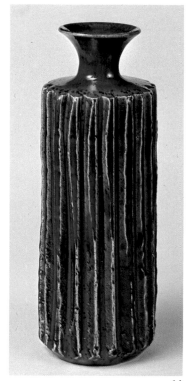

64

65. *water lily*

66. *spatterdock*

67. *pine*

68. *flowering plum*

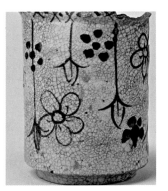

69. *cherry blossoms*

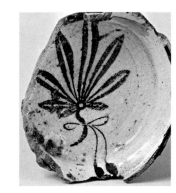

70. *feather fan*

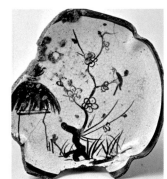

71. *plum tree and bush warbler*

72. *deer*

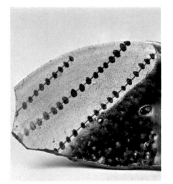

73. *rabbit*

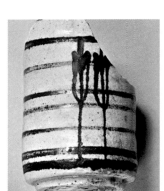

74. *deer*

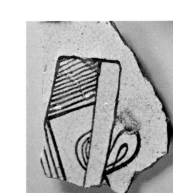

75. *characters*

76. *characters*

77. *dot pattern*

78. *arrows*

79. *geometric design*

80. *dangling clappers*

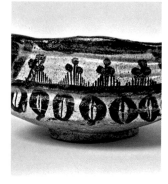

81. *patterns*

Plate Notes

1–3. *Black Oribe teabowl, lily design. D. 15.1 cm. Umezawa Memorial Gallery.*

A large bowl, this example is boldly distorted in the "shoe-shape" style thought to gain its name from the wooden shoes worn by courtiers in ancient times. In contrast to the understatement and sobriety of form of early Raku wares, which were the embodiment of Sen no Rikyū's *wabi* taste, this irregular, warped type of bowl symbolizes the aesthetic of his disciple Furuta Oribe. On the glossy surface glazed in black with a lacquerlike sheen, the white lily stem seems to float. The delicacy of the design contrasts with the powerful, masculine shape of the bowl, enhancing its elegance.

4, 5. *Black Oribe teabowl, belfry design (name: "Dōjōji"). D. 13.8 cm.*

Black glaze, fired to a soft sheen, is applied on large areas of this shallow bowl. The bare clay on the wide base is well fired, displaying the typical clay of Oribe ware. One of the sides is splashed with the image of a belfry and waves, the crude lines on the squat shape giving the bowl a faintly humorous quality.

6, 7. *Narumi Oribe teabowl. D. 14.7 cm.*

This bowl, with its red-tinted body, band of green glaze around the rim, white slip, and iron glaze used in the design, is an outstanding example of the most colorful of Oribe wares, Narumi Oribe. This kind of pottery was once believed to have been made in the Narumi area near Nagoya, and although this has proved erroneous, the style retains the name. One of the best of the many existing Narumi teabowls, this example is outstanding for its bold distortion and subtlety of coloring. It is said that the "T" mark inside the foot is that of the tea ware merchant and amateur potter Shimbei.

8–10. *Black Oribe teabowl, Mt. Fuji design. D. 14.6 cm. Tokyo National Museum.*

A stout band rims this large-mouthed bowl with gentle wheel indentations on the body distorted in the shoe-shaped style. The exposed clay around the base is hard and scant in iron, rather resembling Shino *mogusa* clay. The scorched effect on the foot rim probably resulted from the presence of iron in the shelf or support upon which the bowl was placed. The H-shaped mark on the base outside the foot rim is the mark of the maker. The glazing is enhanced by the contrasts where the black glaze overlaps the white beneath. The side showing the latticed image of Mt. Fuji is usually presented as the front of the teabowl, but the opposite side with its silhouette of Mt. Fuji playfully decorated with childlike scribblings has a certain whimsical charm. The white areas are sometimes taken to represent the roof of a house.

11. *Black Oribe teabowl,* dango *design. D. 12.3 cm. Nezu Art Museum.*

The design, reminiscent of *dango* (skewered rice balls), is cut into one side covered with a lacquerlike layer of iron glaze. The shape is robust and stolid, giving the bowl a character eminently suited to use by warriors of the strife-ridden Momoyama period.

12. *Black Oribe teabowl, geometric design (name: "Shimogare"). D. 14.3 cm.*

This teabowl, although an excavated piece, was obviously used with affection by several generations. The contrasts formed by the white triangular shape and the squared-off black spiral in the adjacent white section give the bowl an ingenuous warmth.

13. *Plain Black Oribe teabowl (name: "Unrin"). D. 14.5 cm.*
Decorated black Oribe is called *kuro Oribe*, while that which is undecorated, as is this example, is called *Oribe–guro*. The bold shape of this piece closely resembles Seto wares, and the brown hues in the black glaze distinguish it among teabowls of this type.

14. *Decorated Oribe pedestaled teabowl (*bajōhai *type). D. 12.8 cm.*

This bowl was probably originally one of a set of *mukōzuke* food dishes. The pedestaled shape, known as *bajōhai*, is believed to have been inspired by the glass wine goblets brought from the West in the sixteenth century. The delicate rings of iron glaze and drips of thin green glaze enhance the bowl's clear-cut lines and slender elegance.

SERVING DISHES

15. *Handled dish. D. 23.8 cm. Idemitsu Museum of Arts.*
This dish is rather deep, stepped in around the sides, and

affixed with a stout handle. The inside is half covered with a thick coating of green glaze, the remaining half gaily decorated with flowerets in iron glaze. On the outside, the green glaze straddles the dish at opposite ends and covers the handle. The reversal of green glaze and designed portions on the inside and outside demonstrates the careful technique of the maker. As in all Oribe serving dishes of this kind, this example rests solidly on three small feet.

16. *Fan-shaped handled dish. L. 29.3 cm.*
Fan-shaped dishes are rare among Oribe wares, and so are dishes with handles. Fan-shaped handled dishes, then, are even rarer, which makes this piece particularly precious. Unusual not only for its shape, the beauty of its glaze and the delicacy of the pampas grass design on the inside is exceptional, making it one of a handful of Oribe masterpieces.

17. *Square dish, tortoiseshell pattern. L. 23.8 cm.*
This square dish is flooded at one corner with a pool of green glaze, the remaining surface displaying a diagonal stripe pattern scattered with linked hexagonal motifs suggesting the tortoise's shell. The harmony of the three colored portions—green glaze and exposed red clay areas with a belt of white between them—is striking. This, and the example with floral scroll design (Plate 18), are both slab-built dishes with a formality not present in pieces made on the wheel. Alongside the many gaily colored Momoyama ceramic wares, these dishes display an especially impressive strength of form and design.

18. *Square dish, floral scroll pattern. L. 21.5 cm.*
Many Oribe serving dishes, as with this example, are half covered with green glaze and half decorated over the bare reddish clay surface. Moreover, it is clear that red and white clay have been adroitly pieced together, accentuating the lush color of the green glaze and enhancing the contrast with the red-decorated portion. If the shrinkage rate of the two clays is even slightly off, however, the two parts would separate in the process of firing, making pieces such as this particularly difficult feats of workmanship. Seeming a simply executed, uncomplicated piece at first glance, more careful scrutiny reveals the calculated pains to which the potter went to create this fine result.

19. *Square dish, stripe pattern. L. 22.7 cm. Nezu Art Museum.*
Stripe patterns are found in handcrafts of almost every part of the world, but seem particularly common among the ceramic wares of East Asia. Their variety is infinite, depending on the color combination and width of the stripes. Here, the simplicity of white glaze stripes bordered with iron-glaze lines against the bare reddish clay is set off by the flow of green glaze over one side of the dish. The striped pattern recalls a fine cotton fabric.

20. *Rectangular lidded dish. L. 23.0 cm.*
Slightly underfired, so that the white glaze remained rather pale, this dish is outstanding for its finely executed designs and strength of form accentuated by the sturdy handle and free-flowing stream of green glaze between opposite corners. Dishes of this kind were often made of lacquered wood, decorated with gold, and made into tiered sets. Such tiered boxes were (and are still) used at New Years' or other seasonal celebrations such as cherry blossom viewing and moon viewing parties. This fine piece shows the mark of several generations of affectionate use.

21. *Fan-shaped lidded dish. L. 29.8 cm.*
Vessels for eating in the shape of fans or other modeled forms vividly demonstrate the sense of modernity characteristic of Oribe ware. Typical of this group of Oribe wares is the method of glazing that combines a plain green-glazed area with a decorated area featuring textile design motifs taken mainly from the Nō costumes popular at the time. This covered dish eloquently crystallizes the sophistication of the arts of the Momoyama period.

22. *Fan-shaped lidded dish. L. 28.4 cm. Umezawa Memorial Gallery.*
Because the lid and bowl must be fired separately, these covered dishes present the potter with a particularly difficult challenge. Many dishes originally intended to have lids are without them. This piece is exceptional for the delicate green hue of the glaze and the detailed workmanship on the cover, featuring radiating and arcing incised lines, combed areas, designs in iron glaze, swaths of green glaze, and a painstakingly modeled handle in the shape of bamboo. The inside of the dish, no less carefully executed, greets the eye with a bright pool of green glaze and scattered flower designs.

23. *Square lidded dish. L. 21.2 cm.*
Oribe ware is particularly rich in the multiplicity of its designs, including animal, human, and abstract motifs of all kinds. Even amid this variety, this dish is unusual. Its motif of a waterwheel submerged in a stream is common in many of the traditional crafts, including textiles and gold-decorated lacquer ware, and is often seen in the paintings of the Rimpa school. Among ceramic wares, however, this is perhaps the only example where the design is so effectively done inside a lidded dish. The amusing figure of a mantis perched pertly on a spray of willow etched in a splotch of iron glaze inside never fails to fascinate.

MUKŌZUKE FOOD DISHES

24. *Square indented* mukōzuke *food dishes. L. 12.4 cm.*
This type of Oribe *mukōzuke* is made with a mold. At close look, impressed traces of the cloth used to facilitate separation of the pots from the mold are visible on the inside. The pieces are distinctive for their design and the peculiar shape.

25. *Plover* mukōzuke *food dishes. L. 13.8 cm.*
Free forms like these flying birds reflect the appreciation of the Momoyama potter for the beauties of his natural environment. The decorations painted between the green-glazed wings have a modern touch of abstraction that recalls the paintings of Paul Klee.

26. *Rhomboid* mukōzuke *food dishes. L. 20.3 cm.*
The Yashichida Oribe kiln, not far from the Ōgaya kiln that produced many famous Shino pieces, was known for pottery with the classic elegance of Kyoto fashion. The dishes are thin-walled, and the delicately carefree designs are mingled with a stray comet of blue glaze and designs in light brown as an intermediary color. The patterns are uninhibited, giving the pieces a very contemporary air.

27. *Crescent-shaped* mukōzuke *food dishes. L. 15.8 cm.*
The crescent-moon shape painted with delicate designs of pampas grass skillfully and subtly links these two images paired in classic Japanese poetry. The streaks of blue glaze splashed randomly in seeming disregard of the grass design augment the special fascination of the pieces. The set is among the most famous made at the Yashichida kiln.

28. *Handled* mukōzuke *food dishes. Hatakeyama Collection.*
Even the most avid devotee of old Oribe is rarely fortunate enough to see a collection of handled *mukōzuke*. This group, bringing together five examples, each different in shape and decoration yet sharing the same overall character, may well be called the king of *mukōzuke* sets.

29. *Openwork* mukōzuke *food dishes. H. 11.3 cm. Umezawa Memorial Gallery.*
Their walls cut out in decorative slits, these dishes were probably used to serve small mounds of food, which probably reached only to the point where the green glaze begins. This kind of deep *mukōzuke*, perforated to reveal glimpses of the delicacy within, are called *nozoki* or "peep-through" dishes, and they are particularly rare.

30. *Boat-shaped* mukōzuke *food dishes. L. 20.8 cm.*
Pleasant to look at as well as to use, this set is typical of Oribe *mukōzuke*. Each is dipped fore and aft in green glaze, the white of their center portions scattered with cherry blossoms.

WATER CONTAINERS AND TEA CADDIES

31. *Tea caddy. H. 11.2 cm.*
A tea container in the classic shape, the cascade of overglaze and the design of dangling persimmons hung to dry make a suitably harmonious combination.

32. *Eared Mino Iga water container. H. 18.6 cm.*
Emulating true Iga ware, which is characterized by a reddish tinge, scorching (*koge*), and glasslike flows of natural ash glaze, iron glaze been dripped on in random fashion on this piece. Its shape is strong like the torso of a country warrior. This is one of the best examples of Mino Iga ware pieces that have been preserved.

33. *Bucket-shaped tea caddy. H. 10.6 cm. Nezu Art Museum.*
Probably this piece was originally part of a set of small *mukōzuke* food dishes. A faithful representation in detail of a real bucket, it is impressive for the uncontrived, yet regular stripes around its body.

34. *Eared Mino Iga water container. H. 20.3 cm.*
A single drip of iron glaze down one side of the purse-shaped body accentuates the effect of the jar's unconventional form.

VASES, INCENSE BOXES, INCENSE BURNERS

35. *Vase, stripe pattern. H. 30.2 cm. Umezawa Memorial Gallery.*
This piece is praised for its stripe pattern, evoking the markings on a Chinese diviner's block. The mouth and foot of the vase are of similar shapes, and the unusual abstract decoration makes it a distinctive piece among Oribe vases.

36. *Incense burner with handles. H. 8.8 cm.*
The green glaze generously applied over the upper portion and handles of this incense burner is of an unusual deep hue. It has an endearing air of feigned simplicity with its tracings of Chinese divination symbols and its stout and somewhat high legs.

37. *Incense box, scroll pattern. H. 4.1 cm. Idemitsu Museum of Arts.*
This Oribe piece lacks the typical green glaze, its squat body is entwined with a scroll pattern outlined in lines of black iron glaze. The bold proportions of the decoration are well suited to the piece's placid form.

38. *Square incense box, human and bird figures. H. 4.3 cm.*
Also without green glaze, this piece is amusingly decorated on one side with a scarecrow figure in a large straw hat looking like a Jizō guardian statue and a sketch of a bird on another. Its lid is affixed with a raised button handle surrounded by four small circular designs, the final touches to its diminutive charm.

39. *Pinnacled incense box (name: "Shigure"). H. 5.4 cm. Idemitsu Museum of Arts.*
The lid of this incense box is tapered in the shape of a simple wayside shrine (*tsujidō*), only the symbolic petals wreathing the tip being dipped in green glaze. This hand-modeled example has much more of the exotic flavor of Momoyama period craftsmanship than other *tsujidō* incense cases made in molds.

40. *Incense box, eggplant shape. H. 7.2 cm.*
Unlike the formal propriety of Chinese-style incense con-

tainers, this example has a whimsical touch, with glaze capping only the stem and calyx of the eggplant. It displays a very Japanese sense of human warmth, yet with elegance. Three supporting feet are cut into the base.

SAKÉ DRINKING VESSELS, EWERS, JARS

41. *Bottle, diadem and grapevine design. H. 24.9 cm.*
This is perhaps the largest existing piece among old Oribe. One side is painted with designs that could be either hanging persimmons or dangling diadems and the other with leaves of a grapevine. The serene design is well suited to the broad, solidly built shape, bearing elegant testimony to the wealth and grand style of the Momoyama age. The characteristics it shares with the ship's bottles (*funa-dokkuri*) of Bizen give it added interest.

42. *Monochrome Oribe saké cups. D. 6.0 cm.*
Among Mino wares, saké cups are all hexagonal and display three types of glazing—green, iron, and Yellow Seto glaze. Today these pieces are included among saké drinking vessels, although when originally made they were known as *choku*, a type of small *mukōzuke* food dish.

43. *Ewer with handle. H. 30.9 cm. Nezu Art Museum.*
Displaying a harmonious blend of all the Oribe colors—green, white, black, and red—this outstanding piece startles even the accomplished connoisseur. All the colors are fresh and distinct, and detail has not been neglected, as in the continuity of lines cut into the rim, the lid's grip, and along the handle.

44. *Saké flask, spatterdock design. H. 19.5 cm.*
The vast majority of Oribe saké flasks are of this tall type, and most, having been found in excavation sites, have needed repairs on the neck portion. This one is no exception. The body is painted with wild spatterdock weed in iron, and the neck and shoulders are covered with a bluish glaze like a sky overhead.

NOVELTY ITEMS

45, 46. *Pipes. Plate 45, L. 12.5–13.4 cm.; Plate 46, L. 7.6–9.6 cm.*
Some are completely glazed in green, some with iron glaze, and others combine green glaze with iron decorations; but all evoke the foreign flavor of pieces influenced by the early exposure to Western culture. Some have a small hole at one end to facilitate cleaning with twisted-paper string. All are excavated pieces that required repair. A most rare example with a monkey clinging to the side is included.

47. *Candleholder figurine. H. 23.4 cm. Umezawa Memorial Gallery.*
Of special interest among Oribe wares are those influenced by the exposure to the foreign—specifically Portuguese—

culture introduced to Japan in the sixteenth century. Prominent examples are the tall glass goblet-shaped *mukōzuke* food dishes and teabowls with the cross used as a design motif. Only about three or four of these candleholders representing the figures of foreigners exist. Since the Portuguese certainly never came as far as the mountains of the Mino area, these pieces are believed to have been especially ordered by Oribe or someone of his acquaintance who was himself in contact with the foreign visitors. One cannot help admiring the humor and exotic flavor so skillfully shown in the facial expression and attire of these figures.

WRITING IMPLEMENTS

48. *Monochrome Oribe inkstone, water-flower design. L. 16.8 cm. Umezawa Memorial Gallery.*
These Oribe examples are the only ceramic inkstones from the Momoyama period save for a rare piece of Bizen. Spatterdock flowerets are scattered in the stylized water pattern on this inkstone, a decoration well suited to the function of the implement. A sturdy, masculine piece, it displays the subtle grace and refinement typical of Momoyama crafts.

49. *Monochrome Oribe inkstone, squash-flower design. L. 17.0 cm. Tokyo National Museum.*
The design on this inkstone is in low relief. These implements were more highly fired than serving utensils, but the piece shows the signs of considerable use. Note the hole in the center of the squash at the right side; water put into this hole beforehand could be run onto the surface by simply tipping the inkstone.

50. *Fish-shaped waterdroppers. Large, 11.1 cm.; small, 9.0 cm.*
These implements used to supply water for grinding ink are called *suiteki* or *kenteki*. The Old Seto ware of the Kamakura and Muromachi periods include tiny jars called *suiteki*. These charming fish-shaped examples are complete with scales, fins, and eyes skillfully incised with a slender bamboo tool in a simple yet extremely lifelike manner.

51. *Monochrome Oribe flower-stamped waterdropper. H. 2.8 cm.*
In the small jar shape of the Old Seto type covered with green Oribe glaze, this piece displays the kinship of Oribe with the ancient Seto wares.

MODERN ORIBE

52. *Monochrome Oribe plate. D. 49.1 cm. Hidetake Andō.*
Andō's standard works employ iron, Shino, and Oribe glazes, and this example is outstanding for the brilliant depth of the Oribe green.

53. *Monochrome Oribe dish, iris design. D. 29.7 cm. Seizō Katō.*
The potter, whose kiln is located near the ancient Moto-yashiki kiln, possesses profound knowledge of the old wares.

This is a fine example of the ancient techniques applied to contemporary wares.

54. *Monochrome Oribe plate. L. 32.3 cm. Yasuo Tamaoki.*
Made by the slab method and decorated with a heavy combing texture, this piece displays great forcefulness.

55. *Narumi Oribe plate. L. 40.7 cm. Toshisada Wakao.*
The Miro-like design gives this plate its abstract, modern air. It is an imaginative piece, superimposing a new dimension on traditional techniques.

56. *Handled dish. D. 23.8 cm. Kiheiji Takiguchi.*
The wiggly handle and stepped-in sides demonstrate the fine craftsmanship in this work. It admirably evokes the vitality of the classical Oribe pieces.

57. *Monochrome Oribe plate. L. 40.2 cm. Osamu Suzuki.*
This is typical of the heroic proportions and exuberant quality of Suzuki's works; its strong form is worthy of the boldest Momoyama period warrior.

58. *Black Oribe teabowl. D. 14.6 cm. Mitsuemon Katō.*
Sometimes unpleasant, the shoe-shaped form seems natural and well balanced in this piece.

59. *Narumi Oribe* mukōzuke *food dishes. W. 16.2 cm. Kōtarō Hayashi.*
The white-glazed pattern, like a web of paddy-field footpaths, forms a striking contrast with the deep green and reddish glazes.

60. *Oak leaf-shaped dishes. L. 23.8 cm. Rosanjin Kitaōji.*
This famous potter, known for his eclectic work, often uses both Oribe and Shino glazes. These leaf-shaped pieces are monochrome green Oribe, outstanding for their refined proportions, vigorous modern forms, and the subdued glow of color.

61. *Handled dish. L. 28.5 cm. Tōkurō Katō.*
A well-known potter of Shino, Oribe, and Setō wares, this is among Tōkurō's finest Oribe works. The fine contrast between the luster of the blue-green glaze and the decorated portion of the dish makes it memorable.

62. *Handled dish. H. 16.4 cm. Takuo Katō.*
This example typifies the ceramic tradition of the Katō family, whose work is carried on by Takuo's father Kōbei and his son Hirohide, both leaders in the production of Mino ceramics.

63. *Narumi Oribe teabowl. D. 13.0 cm. Tadashi Sasaki.*
Sasaki is famous for both Oribe and *tenmoku*-style pieces. This bowl combines an unpretentious shape with simplicity in its fiddlehead fern motif.

64. *Monochrome Oribe flower vase. H. 26.3 cm. Shuntei Katō.*
Shuntei is the second generation of a branch of the famous potters of the Sakusuke Katō family and a leading Seto potter. The ridged form is a fresh touch among the works of modern Oribe.

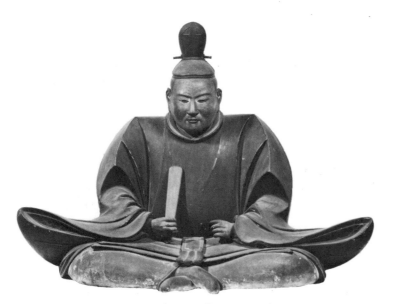

Portrait sculpture of Furuta Oribe.

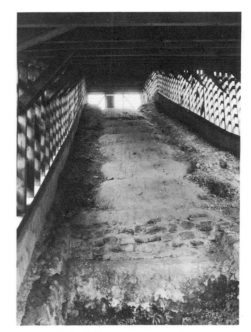

Motoyashiki kiln site at Kujiri.

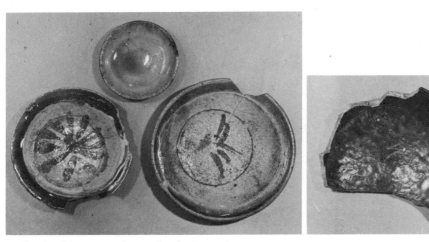

Oribe shards, excavated at Nihonbashi, Tokyo.

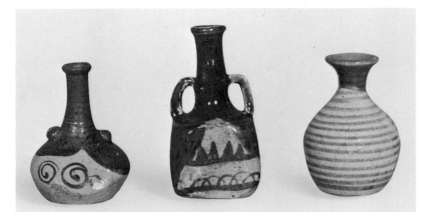

Furidashi (sprinkling bottles).